Thoughts

of a

Collector

To Jan Very Best wishes
A. Everette James
2001

A. Everette James, Jr.
Collector

Published by

WARREN H. GREEN, INC.
8356 Olive Boulevard
St. Louis, Missouri 63132
U.S.A.

© 2000 by **WARREN H. GREEN, INC.**

ISBN No. 0-87527-531-1

Printed in the United States of America

TABLE OF CONTENTS

About the Author
A. Everette James, Jr., Scm, J.D., M.D.

Everette James grew up in a farm community in the coastal plain of North Carolina and credits his mother and aunt with his love of art. Dr. James is an honors graduate of the University of North Carolina and Duke University Medical School. His postdoctoral work was at Johns Hopkins School of Public Health, Harvard Medical School, and as an Honorary Fellow of the Royal Society of Medicine of England. He is a graduate of the Program of Health Systems Management at the Harvard Business School.

James served as a Radiologist in Vietnam where he received the Army and Air Force Commendation Medals and was recommended for the Bronze Star. Later he was awarded the Leadership Award for efforts in behalf of Vietnam Veterans.

James' professional appointments were: Harvard Teaching Fellow (1968-1969), Director of Radiological Research at Johns Hopkins Medical School (1971-1975); Professor of Radiology and Radiological Sciences at Vanderbilt University School of Medicine (1975-1993); Lecturer in Legal Medicine, Department of Medical Administration at Vanderbilt, Senior Research Associate, Vanderbilt Institute for Public Policy Studies, and founder of the Vanderbilt Center for Medical Imaging Research. James was a Scholar of the Institute of Medicine, a Visiting Scientist of the National Cancer Institute/ National Institutes of Health in 1991-1992 and Senior Program Officer of the National Academy of Sciences (IOM) in 1993-94. In 1994-95 he served as the Special Advisor to the Governor of North Carolina and the Board of Science and Technology. Presently he is a clinical professor at George Washington Medical School, lecturer at Johns Hopkins Medical School, adjunct professor and Emeritus Chair at Vanderbilt, and clinical professor at the University of North Carolina.

Dr. James is past President of the Society of Chairmen of Academic Radiology Department (SCARD), past President of the Association of University Radiologist (AUR), and past President of the American Roentgen Ray Society (ARRS). James is a member of the Board of the North Carolina State University School of Veterinary Medicine and served as the President of the Foundation 1997-98. James is a member of the Cosmos and Explorers' Clubs

and serves on the Art Committee of the Cosmos Club. He is a consultant to the National Zoo of the Smithsonian.

Dr. James is affiliated with numerous art-related organizations and museum boards. He has been a guest curator and lecturer both nationally and internationally. His collections of 19th and early 20th American art, North Carolina quilts, North Carolina art pottery, and North Carolina waterfowl decoys have been widely exhibited.

Dr. James, a prolific writer, is author of over 500 articles and 21 books on medicine, law, ethics, art, folklore, and fiction. He is the cover editor of the International Journal of Art in Medicine and has published a monograph on the radiography of paintings. He is listed in 23 Who's Who including Who's Who in Art and is a member of Alpha Omega Alpha.

In 1994, James won the North Carolina Carraway Award for Historic Preservation and is the founder of St. James Place, a museum devoted to Southern Folk Art. He also restored the Bank of Robersonville under the guidance of Preservation North Carolina and the National Trust.

Everette James has three children, Everette James III, Jeannette James Whitson, and Elizabeth Royster James. He is married to Nancy J. Farmer and together they have donated a number of 19th and early 20th century collections of American art to various institutions and charitable organizations. Residing in Chapel Hill, NC, Drs. James and Farmer are active in civic and community affairs.

1
Thoughts of a Collector: Overview

This book is not a primer for financial or emotional success in art. Rather, it should assist you in being a successful collector by providing a variety of criteria. But what is a "collector?" My definition of a collector is a person who enjoys the entire process of acquiring and understanding the desired object as much as the possession and disposition itself. I believe a true collector is someone who attempts to fully participate in all the pleasurable aspects of art collecting. Each object then reflects the potential remembrance of the chase and the personal reflection that you, as the collector, experienced before your decision to acquire was made.

A collector, as opposed to an acquirer, will have objects that are "priceless" to them personally with little regard to their intrinsic value. You may enter a collector's home and in a place of true honor (such as over the mantel) might be a rather undistinguished painting but one of special importance to the collector. For example, my famous American painting collector colleague the late Dan Terra, had a European landscape of little commercial value over his mantel because he said, "it was my first real art purchase." Over my mantel I have a tonalist landscape purchased 20 years ago, after years of negotiation, by trading a car I owned for this lovely but not important work. It is an intrinsically handsome painting and by now reasonably valuable, but it is placed in a position of honor because I traded a friend something he wanted for something he could not bring himself to "sell" me unless the monetary exchange was not the primary consideration of the endeavor. He always insisted the vintage Mercedes never ran, but neither does the painting!

A true collector enjoys exercising creativity in the acquisition of a painting, engaging in at least some of the research to understand the characteristics that make the particular artist desirable, and possibly learning something about the scope and availability of the painter's work. I do not imply from this that your search will necessarily end in someone's attic, storage bin, or an estate sale in an isolated village. You may discover that the best examples of the work of a particular artist are held by an art dealer whose judgement you trust and knowledge you admire. Given this, prepare to pay more but recognize there may be nonmonetary advantages. For example, after considerable study and a great deal of searching, the best Ernest L. Major painting I could locate was

in the Vose Gallery in Boston, a fifth generation American art dealer. Major was an important teacher, technically accomplished but rare. By the time I purchased this painting, I probably knew more about E.L. Major than Mr. Vose did. This included the fact that I was likely paying the world record price at that time, but still fair for this artist. Because it is still the best known example of his work, Vose Gallery and I have used the Major for exhibition loans and illustrations for catalogues and texts many times since. This acquisition resulted in a good investment, despite the fact that it was not the most significant element of my acquisition strategy.

For the real collector, having the best example of an artist is an important element in the pleasure and satisfaction of the process. To make this judgement, you should seek and enjoy the opportunity to see the spectrum of an artist's work. Then you can decide not only the characteristics that make that artist's paintings desirable but what period and expression of their talent you are presently examining and are considering acquiring knowing the spectrum of possibilities. You should remember that artists not only have good and bad days but years and even decades in which their paintings do not measure up to their own standard. I will discuss this many times in this book but would offer this initial observation, one cannot take the dates of an artist's activity and predict when the best work was done. Some were great early in their careers, some began after middle age; and some were still creating master-pieces into their later years.

A number of my American art dealer colleagues, sometimes in collabora-tion with collectors such as myself, specialize in acquiring and making the public aware of the estates of artists and are facile in preparing catalogues and monographs to accompany exhibits and retrospectives of artists' work. This activity provides you as the collector/participant, both an educational oppor-tunity and a unique process you can actively participate in for pleasure as well as for financial profit. I have enjoyed this experience with the estates of several artists including William Chadwick, Marguerite Pearson, and Walter Clark. From this I learned a great deal about these artists. Also from this experience I have later, on my own, located and collected another dozen paintings by them by knowing where to look for examples and what painting qualities I should seek.

The intelligent collector listens to the advice of the experienced and reputable dealers who have earned the position of trust they enjoy in the art community. However, you do not have to accept on blind faith every opinion or pronouncement uttered by any dealer. You should formulate personal opinions, and conventional wisdom should guide you to other personal beliefs, recognizing that your own and public "wisdom" may change. For example, conventional wisdom a decade ago declared that the impressionist

pieces by the Boston artist John J. Enneking were his only truly desirable paintings. However, I had seen several wonderful luminist seascapes executed in the 1880s before his impressionist period that were technically excellent and had great aesthetic appeal. They were not nearly as expensive as Enneking's impressionist paintings and when I found one in a private setting that was a major work in size and composition, I was interested and finally acquired it after some soul searching and over-analysis. The painting was of a familiar subject, Ogunquit Harbor, a location where an artist colony flourished later under Charles Woodbury and his colleagues. The fact the location is known and important is a favorable circumstance for many reasons. My "courage" of this acquisition has been rewarded many fold. This painting has been a magazine cover, used in several articles and texts, loaned for several exhibitions, and subsequently this era of Enneking's work has recently come to be much appreciated as well as much more highly valued than 10 to 20 years ago. It has been "retired" from public display by me and hangs over the mantel in my den where I am often rewarded by its visual presence and the memory of my wisdom in a very successful acquisition.

By that time I was becoming considered, at least by myself and some of my art colleagues, as an astute "contrarian." In this mode I also bought several impressionistic rural landscapes by A.C. Goodwin, rather than the traditional Boston street scenes for which he is best known. These paintings and comparable ones are now considered a desirable part of Goodwin's body of work (also called *oeuvre*). Because they are executed in a slightly different period of Goodwin's career they also provide excellent contrast to the city scenes if you wanted to have a "unit exhibition" to demonstrate the spectrum of his works. The somber, realist, city scenes in colors of the lower register can be placed beside his sparkling landscapes to create an interesting and more vibrant composite.

These examples from my personal experience are not recounted to suggest that you should always fly in the face of conventional wisdom or be in a constant mode of antiestablishment mentality. However, use the knowledge you have and yield to your own impulses if they are based upon reasonable data and careful analysis of your motives. Following your instincts as an informed collector can allow you to acquire significant paintings at modest costs and you may come to be regarded by your colleagues as an innovator as well as an astute and informed collector. Through your independent scholarship, you might make a contribution to the more general public appreciation of a particular artist. Personal inquiry should be part of your credo as an art collector. You should always decide how much of your time and other resources you wish to allocate. In the initiation of my collecting career, I was training for my specialty and had little time and almost no financial resources

but enjoyed the environment because I was at Harvard, strategically located near the Boston Museum of Fine Arts School, the North Shore, and Newburry Street. Despite the handicaps, I learned a lot.

Discipline and self-constraint must be part of your credo also. You can become so fascinated with the activity at auctions and estate sales that you may lose the perspective of what you are attempting to achieve. Public sales and auctions have many risks but they can represent places where a "gem" from private holdings may be publicly offered for the first time, or where a great painting may be sequestered in a general estate sale of furniture, rugs, or other objects (even to used toaster ovens). Conversely, auctions can sometimes be "dumping grounds" where dealers remove paintings from their inventory that they cannot sell privately, they can represent a forum where museums de-access paintings, or where art speculators shop "trade" paintings around. You must be a knowledgable collector to participate in this arena.

The activity of acquiring works in a public forum can be simulated by trading your paintings with other collectors or with dealers for your mutual assessment of "value in kind." This proposal and response, the give and take, as well as the evaluation and appraisal can be just as exciting as holding one's paddle aloft at a sale and feeling the surge of adrenaline that gesture often provides (especially if in the heat of acquirer's passion you are bidding above the figure you had decided upon as your pre-sale limit). You can also feel the agony when told that your closed or "left" bit was next to the last one making you the underbidder by 1000, 500, or 100, or even 50 dollars. Do not mutter "for another... I could have owned...," because this statement discounts the fact that the successful bidder may have been a little old lady in tennis shoes with 20 million in escrow and a several million dollar line of credit. She may have been willing to double or triple her commitment to acquire the painting in question, so your being the underbidder was not relevant.

As a true collector you need to continuously receive education in the marketplace, not just in the reference library of the National Academy, the Fricke Collection, or the Archives of American Art. In turn, you should educate dealers as you are educated by them or the process will not continue in a mutually rewarding fashion. You can allow a dealer to "talk down to you" until you have the opportunity to display your own expertise. After all, every dealer could not possibly know what every well-known collector looks like and only a few of us have name recognition. You should attempt, or at least appear, to be unduly modest because you can learn a great deal when a dealer is attempting to impart enough facts about art and their art environment to bring you "up to speed." This posture is simply paying your dues and the tuition is very inexpensive and efficient compared to learning it all on your own by trial and error and independent study. Display of extraordinary

knowledge to the dealer can shut down this process. Why would they tell a collector who knows everything, anything? So you will get a price quote and that is all.

There will be stages in your reaching maturity as a collector. Do not expect to be satisfied with just accumulating examples of art irrespective of their individual and collective aesthetic appeal. Soon you will begin to analyze your acquisitions and how they fit together as a statement of your intent. The human need to share your treasures may eventually inspire you to loan and exhibit your paintings. This provides you an opportunity to interact with other collectors, museum curators, and the public. A side benefit of this activity can well be other potential acquisitions which may be discovered by you or brought to your attention at this time. People will tell you about paintings they have, a painting a friend of theirs would like to sell, or the work of a certain artist a dealer may have in their gallery.

Understand that at times a seller may be more interested in what you intend to do with a painting than what you are willing to pay for it. One of my more memorable experiences was following an exhibition and a talk I made on restored paintings and my use of x-rays for diagnosis in this healing process. Later a collector came to me stating he had a portrait by Robert Henri which was a good one but needed "healing." When I saw the painting at his house, I knew I wanted to own it. This work represented the boldness and flair of the leader of "the Eight" or Ashcan School. However, it needed some "work," but the seller was more interested in whether I was going to restore the painting and if it would then be suitable for public exhibition. He was reluctant to quote me a price until I assured him that the Henri could be "healed" properly. Candidly, he said the signature was "right" but had been re-enforced some 40 years ago before when the painting had also been relined. This meant to me that due care had been taken when the painting was cleaned before he inherited it over four decades ago. By this time I was becoming slightly nervous about condition, authenticity, and potential total cost because of lack of data. This gentleman was satisfied with his expectation to have people see the painting and responded by announcing to me, in the confines of his home, a figure much less than I had been prepared to offer even taking into account my concerns. At this price I knew I could afford whatever risk I was taking and agreed to his proposal.

Subsequent radiographs of the painting revealed an intact canvas with minimal previous repair and a black light analysis showed a minimally re-enforced signature. Routine cleaning brought out the colors and an inscription to the sitter along with an additional signature. Further research revealed the sitter's identity. I chose not to remove the relining trusting that the style, signature, and provenance obviated the Henri inventory number. The painting

has, subsequently, been the cover of a magazine and in several exhibitions including Henri retrospectives and is currently on long term public loan. An acquirer would have viewed this as an opportunity to acquire an inexpensive Henri, but you as a collector would have been more concerned about salvaging a fine and essentially lost example of an important artist. This might well later include your sharing it with the public.

One of the pleasures of a true collector will be to enjoy the camaraderie and exchange of ideas with other collectors, mutually reveling in the triumphs of successful acquisitions. They appreciate the process that results in a significant purchase, and often become the most helpful in encouraging an aggressive expenditure of funds to acquire an important painting. Certain dealers often act as fellow collectors but the fundamental difference is in the fact that the dealers, however successful and compassionate, have an inventory to dispose of. Art historians and museum curators, while receptive to the process of collecting and appreciative of the aesthetic qualities and historical importance of paintings, are often unaware of the many aspects and pleasures of the collecting process and usually not interested in or knowledgeable about the marketplace value.

Fellow collectors will offer you encouragement in "doing something" with your collection. People like the late John McDonough and the late Bob Coggins were provocateurs as well as inspirations for me. While their collections were more valuable or larger than mine, by sharing their personal experience of exhibiting, loans, and donations, they made me feel that these activities were an integral part of the process and one of the truly pleasurable aspects of being a collector. There are other convivial pleasures awaiting you which are the thread of this text but I will provide a glimpse in this overview.

My first exhibition was at the opening of the new Vanderbilt University Hospital in 1980 and was entitled "American Impressionism." This was shortly followed by an exhibition at the local women's club, called "Paintings of Women." Each exhibition had a different audience. I also decided to make a simple brochure that I enjoyed writing and publishing. Since that time I have had six or eight solo exhibitions, several that traveled to a number of American museums, and have prepared more elaborate brochures and catalogues. As a collector, you may not end with just showing the images of your efforts, which is certainly rewarding, but to convey your thoughts in a written, documentary form is potentially another form of pleasure. There is no obligation to do this, and most collectors will choose not to for a variety of valid reasons (time, security, expense...).

An extension of the gathering process can also be your donation of paintings or an entire collection. This can be for a special person, purpose, or organization that you have a personal or particular interest in or wish to honor.

In reading about the history of American art, you may be inspired by the contributions of collectors like Charles Lang Freer, Frank Butler, Charles A. Hearn, William T. Evans, and more recently, Walter Annenberg, Richard Manoogian, Roger Houston Ogden, Red Blount, Billy Morris, Jack Warner, or Dan Terra, whose collections have formed the bases for national exhibitions and even permanent collection of museums. Most of us do not have the resources to be personally responsible for founding a collection or museum of national stature. However, the experience of donating a modest collection or initiating a small museum for a specific purpose in a community previously under-served by the visual arts can be an exciting and rewarding one for you. I have done this a number of times and can recommend it as time and resources well spent. You will not have an art critic/curator/historian such as Bill Gerdts, Michael Quick, John Wilmerding or a Frank Goodyear to assist you, but you will have an opportunity to consider your own choices of paintings, arrange their sequence and groupings, and can electively assist with the administrative details. You may announce "this offering to the public is personal," and you can experience the joy of doing something original and creative.

After a while you may come to regard your accumulated works as a resource, something of value conceived from a personal love affair, now held by you as a public trust. These resources carry responsibilities but can also be vehicles of influence. You will come to appreciate these facts. The loans, exhibitions, and donations can be very positive forces to bring pleasure to others as well as to educate and to influence the public.

The purpose of this chapter has been to introduce the concept of the competent and true collector and to reveal the myriad of possibilities available to you. Subsequent chapters should remind you of some of these principles and I will treat certain individual topics much more fully. You have the option of reading the chapters sequentially or following the mandate of your own interests and enjoy them individually, even omitting some altogether.

14

2
Getting Started: The Process

The acquisition of paintings and other art forms has many motivations and objectives. John Sloan, a leader of the Ashcan School, felt that "people buy pictures to demonstrate that they have money. Acquiring pictures also leads to a kind of social success." I take issue with Sloan because, in my view, these descriptions characterize "acquirers" and not collectors.

Collectors manifest as many different personal characteristics as do artists, but there are several common traits that are possessed by "competent" collectors. First, they collect what they like, but this self-realization only occurs after a good deal of personal experience in the form of viewing, reading, and discussion with artists, museum curators, knowledgeable dealers, and fellow collectors to the extent they choose. Auctions and museum openings generally provide them a classroom for a quick survey study of art and a social gathering which can allow this necessary interaction with curators, art historians, and fellow collectors or aspiring collectors. Openings are not only pleasurable but you can make them informative; be bold and ask, declare, deliberate, denounce, disagree, and demand data.

After you begin to recognize a preference for a specific genre, subject matter, or painting technique, you will become more focused in the selection of auctions, dealers, and exhibitions. As a competent collector you should dedicate a certain amount of time to the objects you intend to acquire. This is when I initiate the process, not when I write the check. Study the paintings as well as your behavior not only before but after the acquisition. This serves as a manner of consummating the creativity. You are not compelled to "understand" a visual image or your modus operandi (m.o.) in the conventional sense; but you should appreciate it at more than a superficial level. This process may require time for analysis, and processing of your biases and forgotten experiences recorded somewhere in your subconscious. You should devote some time to become knowledgeable and caring about your collection. In this context, you could have acquired a painting without collecting it. Many acquirers of art, either representational or abstract, feel that once they identify the subject or recognize what they believe to be the artist's intent, then they truly understand the painting. Understanding a visual image is a complex process. You will only come to understand some of your collection over time.

You have initiated the process but it is neither a one lane or a one-way street. If you decide to give up ownership of any earlier choice, do not regard it as failure or immutable. There are several other avenues open to you.

You may often find yourself in a state of flux regarding acquisitions and de-accessions reflecting what you prefer at any particular time. This should continuously be refined, resulting in a dynamic of objects being de-accessed, donated, traded, and acquired. Desire, acquire, analyze, refine, de-access, acquire again; for many collectors it is a rewarding and never-ending process. I recommend that at certain intervals you should distance yourself from the immediacy of the process, become more introspective, and give yourself time to think about your possessions. For a while after you have initiated the process, discipline yourself not to collect but to learn.

At first, you may spend a great deal of time analyzing the individual elements of your collection without any overall introspection to characterize you as a genuine collector. Most of us start out as random acquirers and, after we have gathered a few paintings, begin to wonder a bit about where this process is going and if we are receiving full enjoyment from the activity. You should then turn to someone you deem more experienced and ask their opinion and advice. They will be pleased you sought them out. In this context, I will address what I believe is an appropriate initial collection and introspection process using my personal experience with 19th and 20th century American paintings as a paradigm.

Many novice collectors like to state "I collect what I like" and with that have placed themselves in what they believe is a no-lose position. After all, if you have it, by definition you like it, and this response also makes "it" sacrosanct from the judgement of others. Safe, but not scintillating, this posture also obviates the pleasure (and risk) of the opinion of other collectors. It also requires no scholarship, since the acquisition process is presumably based upon intuitive behavior. This position ("I collect what I like"), if viewed exclusively, means that historians, critics and curators can be logically excluded from the process and you never get to know your collection or yourself as a collector. This is not how to start.

You should enjoy the growth process that comes with enlarging your experience and gaining the insight of those knowledgeable in the field. If you start the process correctly, refinement of your tastes will enhance the acquisition and ownership process. Learning about new artists, styles, or movements will often make the acquisition of an example the logical endpoint of an intellectual journey, rather than a reflex response. Remember the"If it itches, scratch it" philosophy. A scratch in the wrong place could lead to bleeding your emotions and finances dry.

I find that many collectors, after some years, are not satisfied with their

acquisitions because they did not understand their paintings or their motives as they were being acquired. Their personal "whole" ended up being even less than "the sum of the parts." That does not mean that an eclectic collection cannot be both rewarding and pleasing, but the chances are less than with a collection which evidences some thought, resolve, and discipline from the beginning. A "statement" collection generally gives the collector more pleasure and is more understandable than an accumulation of random acquisitions.

When I started collecting paintings in the 1970's, I had visited most of the major cities of the world and spent a great deal of time in their museums. From this exposure and initiating process I knew what I wanted to collect. I was more attracted to traditional representational works than the modern and nonrepresentational movements. Landscapes were easy for me to understand and appreciate, and I especially liked the visual effects and the light colors of impressionism. For a decade, I followed this commitment. More recently I have, because of some independent study, included a number of examples of related artistic movements such as the Barbizon aesthetic and tonalism. I also became interested in examples from certain art colonies that used modified versions of these techniques such as Old Lyme, Connecticut; Rockport, Massachusetts; New Hope, Pennsylvania; and Brown County, Indiana.

As important as deciding on the style and subject matter you wish to collect, is first determining the level, amount of time, and financial commitment you would feel comfortable with. What do you want to achieve? Two physician colleagues of mine were very well-known and highly regarded collectors. One owned as many as several thousand paintings, and the other once told me that he wanted "only a dozen or so great paintings." These goals dictate a markedly different collecting style and would suggest a different resource allocation for each example. If you enjoy collecting a large number of paintings, you are much less likely to feel comfortable with or can afford a large expenditure for any single great example by a well-known and highly desirable artist. This is a much different posture than a collector who acquires one or two paintings a year. My adage is "pay more, buy less," but that also depends upon the anticipated final result — the intent you have in acquiring the collection. There are all manner of motivations for collecting art, and you should examine yours and realize that any change of intent will definitely affect your collecting strategy. At some time, you may rethink and redefine your goals to make your collection have a more clearly identifiable theme. Your paintings will no longer be a random collection of pleasing images but the individual elements of a definable whole.

Over the years, as I gained confidence in my choices and began to share my collection with the public, I soon recognized that even my initial collecting was

influenced by my loans and exhibitions of the paintings I had. For example, the half dozen, almost life-sized female figure paintings (70" x 40") I acquired because they were great values, are also more appropriate for Grand Central's La Femme exhibit or the Art in Embassies program of the U.S. Department of State than they are for almost any home, including my own. Fortunately I was an early participant in each of these undertakings.

Public display of my paintings has also made me very "frame conscious" and I make every effort to restore the original frames if they substantially add to the visual impression of the work. If the frame detracts or does not particularly embellish the painting, however, I will opt for a period reproduction or a refurbished period frame. The final appearance of the composite entity can even be calculated initially into your collection strategy.

The collector should begin with the intent to enjoy not only the result of their acquisitions, but the process itself. Some introspection will lead you to an enhanced understanding of your first motivations and provide reasonable criteria to re-initiate the process and later judge the success of your efforts. You are ready to begin the process again by choosing another painting to acquire.

Most collectors believe that selecting a painting is a formidable exercise and may even feel intimidated by the prospect. If you truly believe this, you initially may have someone else determine the suitability of a particular work for you. In this instance, the person you select as your agent should have intimate knowledge of your needs, desires, and resources. Alternatively, you can "buy what I like", and through an often lengthy process of trial and error, you may learn what that expression really means to you. "What I like" may change often and quite rapidly at first. I would not recommend either of these approaches. Probably the most satisfying method of acquisition is for you to develop some personal skills in evaluating paintings and, with the assistance of a reputable dealer, art consultant, or auction house representative, eventually make your own first choices.

The final criterion in evaluating a painting is its specific desirability to you as the collector, and that is largely a personal judgement and difficult to determine initially. Do not feel you have to be "right" or "wrong." Individual collectors have their own visual perception, sense of values, and personal interests that combine to make them uniquely qualified to, in general, render this evaluation fairly accurately for themselves. After all, it is *your* collection, so do not be faint of heart. The time to begin will always be "now," and never "tomorrow."

3

Choosing Your Art Dealer

Collecting art should be a very pleasurable activity and having the good offices and best judgement of an appropriate dealer or dealers is fundamental to this process. You should attempt to match your interests and resources with your dealer or dealers. This often requires considerable effort, but certain measures can improve your chances of a proper choice.

Collectors should first assess why they collect and what they wish to collect. Identify your expectations and assess how much of your overall resources you are willing to commit to this process. Doing this with some degree of accuracy and conviction will be helpful. Then have fellow collectors suggest dealers whose inventory, interests, and style might fulfill your defined needs.

There are many reasons to collect paintings and various techniques to do so. If you want to have a few beautiful objects and are not interested in any particular artistic style, period, or subject matter, a dealer with a large inventory of paintings from different periods will serve you well. If, after some experience and independent scholarship, you have decided to acquire a particular painting style and period, you can choose a dealer who specializes in these types of paintings.

After you visit a few dealers, you will realize that they, too, have different styles. Some dealers like to display their inventory, answer any queries, and then leave you largely on your own in the selection process. Other dealers will suggest several paintings or one in particular that they believe might be most appropriate. Some dealers develop a "Duveen countenance" in which they select a painting for you and present the work as a *fait accompli*. Most dealers have expertise that can allow them to be very helpful in each type of relationship.

If you decide to collect major examples by major artists, your dealer will play a large role in making these works available to you. However, if your decision is to collect major examples by lesser-known artists, you can probably function much more independently because you can do much of the scholarship and search for the examples yourself. Your dealer may or may not have paintings by these artists and some dealers do not enjoy this type relationship with their collectors. If either the collector or dealer feels uncomfortable with their role in the process, they should dissolve the relationship and

remain colleagues.

Some dealers pride themselves on long-term relationships with their collectors. They have gallery policies regarding returns, trades, consignments, and even payment schedules that reflect this attitude. If you acquire a painting, these dealers will allow you to return it, providing this happens in a reasonable amount of time. Some dealers will allow you to trade a former purchase from them for equal value if your collecting interests change. They may also take the work on consignment if you want to de-access it, and sometimes introduce you to another collector or a dealer who might like to acquire your painting. These options characterize dealers who have taken a very responsible view of their role in assisting collectors and cultivate long-term relationships.

Some collectors feel a responsibility and desire to share their paintings through exhibition. They often collect paintings according to exhibition themes. Certain dealers also enjoy the opportunity to participate in this sharing process by exhibition. I have collected various themes for exhibition and subsequent donation as collections such as examples of "the Boston Museum School" and "Indiana Impressionism." It soon became apparent that major examples of such artists as Tarbell, Benson, DeCamp, Steele, and Paxton were beyond my resources if I planned to purchase more than an occasional painting. In order to acquire a representative collection of these artists today would require at least several million dollars.

While I am a great proponent of established dealers, I decided to explore another group, the "pickers," who are not conventional dealers but can be another resource for art collectors. These itinerant gatherers are also a source of supply for dealers with galleries. While there is a great temptation for a collector to purchase paintings directly from pickers, there are definite hazards in acquiring paintings by this process. A collector will lose many safeguards that a long-standing relationship with a reputable dealer provides and is at the mercy of his own judgment regarding authenticity and condition of the paintings. Pickers acquire works in a certain manner and operate in a time frame that precludes a great deal of knowledge regarding the provenance and exhibition record of any particular painting. Another reason for the collector to be cautious in acquiring in this manner is that by removing the established dealer, the supply and demand are affected.

You should expect to pay for the expertise of a dealer, his cost of having the gallery open to the public, and for the assurances you have when acquiring paintings from someone who will be "present" for any future eventuality. The service provided by a helpful dealer is valuable and has a price not unlike that of any other professional. Do you buy stocks from "cold calls" at home or real estate from a mail brochure?

Regionalist interests may take your collecting activity to areas where

paintings can still be located privately in homes or in malls and small antique shops. For example, the Indiana Hoosier School of Impressionism consists of a body of paintings that are available from a wide variety of sources. Several dealers in this region have participated with collectors in acquiring a number of paintings from this school. If you choose to enter into one of these collaborative arrangements, you should select a dealer who has an art historian's interest combined with a great deal of energy.

Most dealers are knowledgeable about painting condition, framing, and the cost of restoring a specific work, but some are not. In a joint venture, be certain that you or your partner(s) are. Make certain, by documentation, that the expectations of all parties are well understood and that a definite time is set to consummate the acquisition, distribution, and planned disposition of the paintings.

Personal style is very important to both the collector and dealer. Many collectors want to have a single dealer and will defer to them when exhibiting their paintings to the public. Other collectors, like myself, take great pride in presenting their collection personally as well as conveying their particular acquisition philosophy. This group of collectors will usually have several dealers which requires a less personal relationship than if they have a single dealer. However, this arrangement can still be satisfying to both dealer and collector because each individual acquisition may contribute to the whole. You can be proud and your dealer satisfied from the transfer of any single painting to add to the theme.

Many collectors feel intimidated by well-known and famous dealers. You may assume that your resources and aspirations are too modest to be worth the time or attention of these legends. In general, successful dealers have become well-known because they are clever, characteristically expend a great deal of effort for their clients, and have a sense of "where they came from and how they got there." Most dealers respect candor, and if you tell them what your resources for the acquisition of paintings are, they will guide you to select value for the commitment you make.

You may not be able to purchase all of the paintings you want to acquire outright. Trading, as in kind exchange of paintings, can be an interesting part of the process, and arriving at a mutual agreement of equal value will require bilateral trust, but the process can be facilitated by a dealer. Your dealer can also arrange financing.

Let me discuss one very common myth. There are no exclusive or unapproachable dealers. There are some whose usual inventory may exceed your means; but, for all they know, you may be the next Wendell Cherry, William T. Evans, Charles Lang Freer, Richard Manoogian, Walter Annenberg, or Malcolm Forbes. You can establish an intellectual relationship with dealers

and show them that you are interested in their inventory, even if you have not made a purchase from them. If you demonstrate enthusiasm and a desire to learn, most dealers will respond. After all, there are other kinds of rewards for them besides strict commerce.

Again, the key is to examine yourself and have a clear idea of what you want as a collector. Then, choosing the correct dealer will evolve naturally from this knowledge.

Your choice of a dealer is a significant one, but just like annulment, separation, and divorce, you can change the arrangements. The expression may be trite but "some of my very best friends are dealers."

4
Choosing a Painting

Collectors often wish to know where to begin and ask me about the initiation. The generic answer is, as I have noted, go to wherever the greatest spectrum of art is exhibited for you to see and learn about. You should visit as many museums as possible, view the offerings at the large auction houses, and attend discussions and lectures on paintings and techniques that have even a remote chance of being interesting and informative to you. You should review as many auction catalogues, art books, exhibition monographs, and atlases as makes sense for your life-style, and how knowledgeable you want to be. After a general survey of art history, auction catalogues are very helpful to reinforce the visual images and for you to determine the specifics of those you want to collect and become aware of fair market value. Soon, the style of art, painting technique, and subject matter that you prefer will be identified. Once this has been established, the next step for you is to structure your reading of art texts specializing in this genre and begin visiting dealers who offer this particular art for sale. You should attend auctions where these paintings are being offered and observe the process and record the prices achieved. This is akin to charting stock prices before investing in them, having land surveyed, or getting your own "estimate." This exercise will provide you a sense of the most important artists painting with a particular technique, their general price range, and what characterizes the representative and most collectible works for the individual painter.

From reading about painting techniques and viewing examples on public exhibition, you should and will gain some knowledge of how to evaluate the composition of a painting and whether the elements are appropriately utilized to create a competent and pleasing work that will endure. You should also develop some skill in evaluating the condition of a painting and whether any conservation or restoration will be required. The condition of the pigment and outer layers exterior to the support are of great importance in evaluating the status of a painting. If the condition is poor, restoration can be costly and so extensive that very little of the original work of the artist remains after this process. Visual inspection can provide an overview of the condition of a work, but a personal "black light" viewing for inpainting, signature reinforcement or addition, and overpaint should be a standard part of your routine. Dealers and

auction houses will usually provide a condition report upon request. However, you should utilize your personal assessment as well as the report of the seller before judging the condition and thus suitability of a painting for acquisition, before you purchase it. This applies to all transactions and not just the private ones.

Several assessments can only be made after you have had experience in evaluating many paintings, so you may have to deal with your inexperience. In comparing an individual painting with the spectrum of works by that artist, you will either depend upon the seller or recognize that you cannot make this assessment initially. Is this the best, the worst of their spectrum, or something in between? Think about a 1 to 10 in evaluation generically and you will usually be correct.

The "provenance" (pedigree) and exhibition record of the painting should be requested before you consider purchasing it. I am amazed at my colleagues who do not do this; it can be very important. The pedigree can add substantially to the importance and desirability of any particular work. Why and how? Painters generally submit their best works to important exhibitions and juried shows. To be included, they must meet certain criteria. Therefore, paintings selected by the artist to be included in exhibitions will generally have greater appeal and value than just a representative example. This is why labels and documents are important if they are available. You should always seek the pedigree in determining whether to make an acquisition. However, some judgment should be exercised in evaluating the provenance; "from the estate of the artist" may not mean that it was retained as a personal treasure by the artist. The painter may have been dissatisfied with the work and thus not have offered it for sale.

The name of a famous gallery on a stretcher label enhances the value of a painting but may mean that they de-accessed it by "dumping" at auction. The dealer may also have placed the work on consignment with another dealer and the painting failed to sell in the secondary market. A well-known museum could have purged the work from their holdings as an example they did not want to exhibit and they might gain both space and money by selling it. Thus, provenance is usually a positive, but not always as it can even lessen the value of a painting. Use your eye and don't succumb to just "label collecting."

Ownership by an astute collector, if established, can add value to any work. If the painting has been exhibited, judged, and then received an award, these phenomena will also enhance its value. I once bought a painting that had been poorly relined. When I removed this, both a stencil mark identifying the canvas as French and the label imprint of a title and date could be seen. The painting had been exhibited at the Paris Salon in 1893 substantially increasing its value and interest to me. You as a collector, in uncovering this type of data, have an

opportunity to experience one of the singular joys of the acquisition process. Many dealers will do the prerequisite research for the prospective client, but while the information is important to you, it is more fulfilling for you to acquire the data yourself.

The final criterion in evaluating a painting is its specific desirability to you as the collector, and that is largely a personal judgement. Individual collectors can have their own visual perception, sense of values, and personal interests that combine to make them uniquely qualified with the prerequisite data to render this evaluation. After all, it is your collection. Choosing a painting is a very enjoyable process — no matter how inexact; mistakes are reversible, your tastes may change, and the intellectual experience is often exhilarating. My advice is to be an active part of the initial process because you know your needs and the extent of your resources best.

5
Quality: The Ultimate Criterion

Quality is the single characteristic that every collector of art objects should come to understand and discipline themselves never to deviate from. Condition, artistic style, visual appeal, the stature of the artist, provenance, and exhibition record of that work are part of the determination of quality. It is the totality of these assessments that adds to your overall judgement of the desirability based upon a quality judgement. The definition of quality depends upon the category of object the collector is seeking to acquire. Folk art has different criteria for the assessment of "quality" than does classical sculpture. A collector who wishes to view quality examples of American impressionism, the Hudson River School, or realism, for example, needs only to visit a number of museums and commercial galleries in major cities. These museums and galleries have enjoyed a long-standing and much deserved reputation for exhibiting excellent examples by the leading schools and the more accomplished painters. They should have had years of benefit of an informed director, a trained and accomplished curator, and donations from the best of their membership.

You will benefit from the expertise of the gallery staff in the auction houses as well because they have pre-selected quality paintings which they present in suitable condition for sale. The same can be said of dealers with good reputations. For such service and expertise from a dealer, you will probably pay premium prices. I equate this mode of acquisition with the purchase of an insurance policy, to some extent guaranteeing the painting by providing you a potential mechanism for later de-accession of the work if it does not meet your expectations or if you wish to change or upgrade your collection. For most collectors especially the inexperienced, purchasing from a well-known gallery is a very appropriate and, I believe, the preferred method of acquisition. It is generally safe and uncomplicated, and requires less mental and physical effort regarding the assessment of quality by you . Make certain, however, that this is a learning process and not a passive one. Challenge your dealer colleague to "convince" you through data of the wisdom of the purchase. Find out all they know about the artist, the school, the provenance, the condition, and comparable works that have recently sold.

Should you decide to judge quality entirely by yourself, the responsibility

for your investment is commensurately increased. How might you proceed to become a judge of quality? First acquire a thorough understanding and measure of quality regarding the particular artistic style you intend to collect. Impressionist works, for example, should exhibit those painterly elements resulting from de-emphasis of line, the use of color to produce form, and the result of employing pigments of the higher register to impart a light or "blond" palette. A desirable example of impressionism should contain, as well, juxtaposition of contrasting pigment to convey movement and a conceptual rather than a perceptual emphasis of form and composition. The most common subject matter of impressionism will be the sun-drenched landscape. Subject matter is not a rigid criteria, however.

Once able to identify these elements, it is important for you to be able to assess the overall composition. Is the geometry of the objects in the composition correct regarding spatial relationships and the relative sizes of objects? If the perspective of a painting is incorrect, the work will appear "stiff" and unbalanced. Knowledgeable dealers will avoid this type of painting, or if one appears in their inventory, they will sometimes offer it as a "bargain," de-access it at auction, or give it to a "lesser" dealer. You should beware of these because such a painting is not a "bargain" almost irrespective of the price because it lacks the technical qualities that make the artist and the style desirable. Use your eye not your hip pocket to make the decision.

If you want to acquire an atypical example of an artist, then the painting should possess excellent technical qualities and be acquired inexpensively. I have acquired paintings from time to time that were considered "atypical" but later with further scholarship about the artist became typical. These acquisitions increased in value many fold. You can be a contrarian on occasion but don't make it a career. Too many atypical paintings make an atypical collection.

Blind faith purchases from even well-known dealers are not prudent and I am not suggesting that you should ever acquire a painting this way. No matter how well versed, a dealer is not an expert in all areas of art, and no amount of education or experience will render him competent in the entire field of painting. All dealers have an area of specialization and expertise and often enter the art business from different avenues. Some dealers were born into the art business, while others were "academics" who, after their formalized study, became curators or art historians. They later elected to enter the marketplace. A number of dealers have been Directors of Painting for auction houses. Other dealers began as collectors (or believed that they were collectors) and later became dealers. Their concept of quality will retain the bias as to how they came into the commercial art world.

The dealer's style of interacting with you may be significantly influenced

by their background. In fact, you can often diagnose the background of a dealer by how they approach the marketing of their inventory and how they regard "quality." The former art scholar will usually know a great deal about the artists themselves but not as much about the marketplace value of an artist's work. They will, however, be knowledgeable about the characteristic example. In this circumstance, you must evaluate typicality of that work from your own perspective and only if you have seen enough paintings by the artist.

Dealers coming from the active world of the auction house have often seen a number of examples of a given artist's work. They will usually have an opinion of the quality of a particular painting by an artist as they can judge it in relation to others they have seen. These dealers are less likely to place as much emphasis upon the artist's credentials or the provenance, but more upon the visual appeal of the painting. Again you can contribute significantly to the assessment of quality by knowing the pedigree of that artist.

Dealers born to the trade often understand the history of the field and have been aware of the comings and goings of paintings as well as the spectrum of work of artists their family has sold in the past. When a painting by an unfamiliar artist comes to their attention, they often show little inclination to research the work. They will judge it on artistic quality alone and price it accordingly. This may provide you an opportunity for a true bargain if it is by an artist they are simply not interested in and you know or can acquire the appropriate data.

With regard to the subject of quality, a number of famous collectors have said "I can't tell you what the quality is, but I know it when I see it." Quality is, indeed, a subjective term and reflects the bias and experience of the observer. There are, however, several considerations in discerning quality which I think are valid. The first is your initial visual response. A painting which stands out when placed with a number of other works by that artist or with paintings by others demonstrating the same style or subject matter has at least one type of quality. If a painting catches your attention from a distance, then move closer to evaluate the technical quality. A quality landscape, for example, will show depth of field and perspective from any distance at which you can see the individual elements. An impressionist work should be bright and sparkling and have enough broken color and contrast of colors to project a feeling of movement. Dark, dull paintings and those having few structures or figures may be technically correct, but as impressionist works they would rarely be described as quality examples.

Certain themes often increase the perception of "quality" in a work. For example, in a landscape or depiction of a seashore, the inclusion of human figures adds interest and excitement to the painting. The play of light and shade upon a natural reflective surface in a seascape will demonstrate the technical

expertise of the artist.

Faithful portrayal of natural phenomena adds greatly to the desirability and "quality" of a painting. Certain artistic license may stimulate or add interest to the painting, but it should still be composed in a credible manner. Not every painterly work of American impressionism is bright and sparkling, but you should be critical and studiously analytical in judging the quality of a painting that is not.

One of the tenets in astute collecting is that examples of artists should be from their "good" period. This is an important concept that should not be oversimplified. Most classically trained artists have various passages in their career imposed by their experience. Thus it is quite understandable that with many artists, you will see "student" or academic pieces first and more creative and unique ones later. Some of these early works will be interesting and possibly be even accomplished, but reflect the needs of the course of study, the artist's mentor, or the influence of fellow students. They are not the artist's statement. After you have seen the spectrum of an artist, you come to understand the changes over time in the appearance.

As an artist goes through the rites of passage in the school from still life, figure study, landscape... there will be examples produced that may well demonstrate talent, but will not represent the works that later make the artist desirable. Often the outstanding draftsmanship skill of that artist will be demonstrated and may result in an aesthetically pleasing example, but this will not represent the most desirable period for the artist by definition. These are the required exercises leading to the later personal expression.

Paintings are usually categorized by subject matter such as portraiture, still life, figural, landscape... certain artists have mastered the artistic techniques of painting so well and have such overall ability that their desirable works span a variety of genre and subject matter. For example, William Merritt Chase, following his training in Munich, became the leading teacher at the Art Students' League and ran a very successful summer school at Shinnecock on Long Island. His vibrant landscapes often contained figures as did his wonderful interior works. Chase's still lifes are also very accomplished and highly desirable. Many of Chase's portraits are celebrated and often used as examples of outstanding American art. Thus, almost any subject by Chase is desirable _ and expensive. His range of accomplishment makes him stand apart. Most artists will be much better at certain subject matter.

In a manner not unlike that of handwriting deterioration, most humans experience the same phenomenon in the fashioning of their art. For some, it is an artistic "rigor mortis" and their compositions become stiff and formulaic in the later years or if they become very "commercial." For example, the beach scenes of Edward Potthast became crude and stiff late in his career. He became

less facile in the composition of his figures and with the play of the blazing sun upon the water and bright sand. In fact, the figures in his later works seemed to be almost added as an afterthought. These small "pot boilers" do not compare with his spontaneous and flowing major works with figures engaged in pleasurable activity at the beach. The "pot boilers" are not cheap, and they are certainly not what you want to acquire as your example of his work.

George Inness, considered by many to be America's greatest intimate landscape artist, provides us with many choices as to his "best period." Early in his career, his landscapes were crisp and precise. Later in the so-called middle period, they became more painterly and lighter in palette, yet his works continued to have a very definite, representational quality. In his third period beginning in the early 1890s, Inness combined tonalism and certain techniques of impressionism to produce works of great evocative qualities. Inness, just before his death in 1894, was arguably an accomplished impressionist. More importantly, his later works, at first not appreciated as a true manifestation of his great talent, have now come to be regarded as the equal to those of the other periods. Inness is very well documented in Ireland's book, the writings of Nick Cikovsky, and now a *catalogue raisonne* by Michael Quick. Almost anything except the dark, "muddy" paintings by Inness are good choices. One can simply use their own tastes to select from these periods.

Sometimes an artist will have proponents who are convinced, and offer compelling arguments to provide the idea, that only one period represents the artist's desirable period. They are certainly examples to the contrary. Will Henry Stevens was an accomplished impressionist who later became a leader of the modernist movement. He is best known for his more abstract nonrepresentational works, his impressionist paintings are less avidly collected, but all paintings by Stevens are desirable and it is a matter of your choice as which to acquire. I have two of his impressionist works that I am very pleased to own.

An integral part of the quality assessment is judging the period of a painting in relation to the artist's entire career. You want to always acquire paintings that represent the best qualities of the artist. The "right" period will produce paintings of lasting qualities that affirm your favorable opinion to scholars, dealers, and your fellow collectors. You will want to have them share in your pleasure of the acquisition and respect the thought you employed in making your decision. They will also wear well on you. It is like an ensemble with good tailoring.

Should you ever knowingly acquire a painting that is in the wrong period or atypical for that particular artist, I have no easy or correct answer for this but would tell you not to commit significant resources to this acquisition. If the painting is technically outstanding or particularly attractive from aesthetic criteria, you might acquire it if it is a fraction of the price of a more typical

example of the artist's paintings. Like the investor contrarian, the collector electing to go against the grain should have clearly in mind the reason for doing so. The "I buy what I like" philosophy should have knowledge as its foundation, not simply a visual gut response.

I believe that condition has received too little emphasis in the literature about the valuation of paintings. Many collectors and even dealers feel this is a technical subject and writers seem to feel that discussion of this may not be of interest to most collectors; but I think it is so important it should be emphasized rather than neglected and should be a subject of discussion and re-discussion. Quality means that the painting is in good condition or a condition such that it can be rehabilitated with little change from the original. Presumably, the dealer will have made this assessment for you. The consignor to an auction house, however, will not, so you are dependent upon the condition report of the auction house itself. Many transactions between private parties occur in such a manner that you are on your own in determining condition and you certainly are with a picker.

A painting can be viewed as a perishable item that begins to "spoil" the moment it is constructed. Just exactly where a work is in the spectrum of this inexorable deterioration process at the time you might wish to acquire it requires your accurate condition assessment. Visual inspection can be surprisingly accurate when performed by an expert. This requires experience, and even the most astute can be aided by scientific, objective studies.

Certain questions can be posed by the potential acquirer to the seller that are standard and should not be considered provocative but should be considered reasonable. Has the painting been cleaned or relined? Is there "inpainting?" Are these the original stretcher and frame? Is it signed and is the signature "right?" If the seller fails to be candid in their response, check for the location of the exit! If these routine questions are answered with proper specificity, then you will still want to confirm these responses by your own evaluation. "Black light" inspection will allow you to assess how much inpainting there is. I have two black lights, one battery operated which is small and will fit into my pocket, and another larger plug-in type. At the proper Angstrom level the newer applied pigment will be much darker than the hazy blue background of original paint. Suppose the signature had been "reinforced." That is not ideal but certainly superior to a fake one that will be seen as dark and homogenous.

The pigment layer of a painting is a composition of various suspending agents and particulate material that have different responses to light and atmosphere. Therefore, these components dry and shrink in their own characteristic manner and cause the image layer to "crack." As this deterioration progresses, areas of pigment may separate from the canvas (or a more ridgid support) and flake, producing an unsightly part of the image devoid of

pigment. This may have been inpainted in the past. Determining how much of this process has already occurred and may well be necessary in the future is an important assessment in your determining condition of the painting offered and you can do this with your "black light" in a room that is dark or has greatly subdued light.

So when you discover a Kensett with 40% inpainting by the local restorer, what is the value of a 60% Kensett? A good Kensett could be worth $300 — 450,000, but is a 60% worth $200,000, $20,000 or $2,000? Now if your possible acquisition were an absolutely "unique" painting (the Mona Lisa or a previously undiscovered Velasquez) then you might still acquire the work even though much of it is not by the original hand.

The condition of the support upon which the pigment or picture layer is applied represents a major determination for the would-be acquirer. "Canvas" is made up of linen, cotton, sometimes silk... and other materials. Most canvases are of a linen composition which is subject to the various changes that occur in different circumstances due to sunlight, mold, heat, moisture... so that the support may be unstable and will require the application of a fresh canvas behind (relining) to add to its strength. This relining process can be both expensive and will change some of the surface properties affecting the image. Discussing this with the seller and possibly a conservator is prudent collector behavior if considerable funds are to be involved in your purchase.

Sometimes an x-ray study will give you an overview of the condition of the support and reveal whether the necessary area of treatment which can be confined to a particular area or must involve the entire support. Smaller area patches may not alter the overall appearance of the image and x-rays will often tell you how much needs to be reinforced. If the painting has been relined, determine if the applied canvas fits well and uniformly, if not, you may have to remove it. This can be difficult because there are inexpensive reliner canvases that are applied with glue. They do not hold well and are difficult to remove, so beware.

One of the great joys of a collector is to find a dull painting with considerable surface dirt and grime and yellowed varnish that after a simple cleaning will result in a bright, sparkling gem. If you believe this to be the condition of the proffered work, you may be in the position to make a truly satisfying acquisition. However, if the painting has already been cleaned, make absolutely certain it has not been overcleaned, often referred to as "skinned." Removing too much of the pigment surface may have obviated the impasto effect of an impressionist's work or simply scraped off significant pigment of a 19th century portrait greatly devaluing both paintings. Any rehabilitation will compromise the "genuineness" of the painting and considerably lower its value.

You should never acquire any painting until you have assessed its condition and have confidence in the validity of this analysis. A painting in poor condition will not bring you long-term satisfaction from ownership, will only deteriorate (and more rapidly than a painting in good condition), and will be difficult to sell, trade, or even donate. You will always be unhappy with it and that is what collecting should be about; pleasure to you.

After this discussion you may ask where is the best place to acquire a painting. This is not a simple answer, but I most often buy from well-known dealers. Some of my more adventuresome acquisitions are acquired at auctions. Trading with other collectors should only come after you have a number of paintings and have earned the respect and trust of these valuable colleagues. Even after diligent scholarship in an area of collecting, you can still learn from dealers because their "need to know" about this subject is greater than yours. After all, dealers must convince you to acquire a painting and they should do this with data and not a stimulation of your emotional response. Name dropping of the imaginary price that a well-known collector paid to acquire an example similar to the one offered me tends to increase my resistance, not my acquisitive resolve.

Quality is almost an all-inclusive term and might seem to be an elusive definition; but with practice, you will come to know what this concept represents. This entire process is greatly assisted by your having initially a mentor who may be a respected dealer, a fellow collector, or the experienced director of your museum. These arrangements will not guarantee your complete success, but will enhance your pleasure as a collector of quality examples of your genre of interest.

In the final analysis, the choice and decision about quality should rest with you. Expert opinions by others are data to add to your body of knowledge, but the final judgement of this important criterion before the acquisition of any painting is yours. Quality for the experienced collector is sometimes easier to recognize than to articulate. After awhile it will almost become intuitive, but you should be methodical in your analysis and trusting of others only to a point. After all, you are going to have to live with the decision.

6

On the Trail: Bring What you Need

Many collectors delight in utilizing their own knowledge and tastes to acquire art objects, hopefully at below their actual value. The hunt has the spirit of adventure and the excitement of uncertainty. Part of the uncertainty and related excitement will be due to the fact that you will not have the benefit (or the challenge) of a knowledgeable seller, the opinion of a conservator regarding the condition of the work, an adequate provenance, or a validated signature if one is present at all. You have the opportunity, however, to acquire a real treasure, if you have sufficient personal knowledge to ensure that you make a prudent choice. If successful, it gives you an affirmation of your expertise and good judgement unmatched in conventional purchase methods.

Finding "bargains" may involve a search in obscure and sometimes isolated places with only a remote chance of uncovering a true treasure. You may find yourself in an antique mall next to the socks and undershirts, or in a junk (sometimes spelled "junque" but junk nonetheless) shop winding through vintage washing machines, farm implements, and vacuum cleaners. The tag on the painting may be such a revelation as "oil picture," "early work," or "listed artist." To embellish this information, the tag might say "from an estate" or "found in...". The helpful proprietor may also inform you that "this picture has some age on it."

Given no more database than this, you are definitely left to your own devices. If knowledge is power, then you are rendered powerless by the information provided. Accepting this circumstance, you, as a wise and seasoned collector, should plan to gather the necessary information to make an educated decision about the authenticity and condition of the painting your-self. To acquire the necessary data, even the most astute collector should never enter an antique mall, junk shop, or even an estate sale without the proper equipment. Your gear should include a portable black light, a magnifying glass, a multipurpose knife, and a reference text featuring those artists you collect.

The condition of a painting is a major determinant in its potential value. This has implications of risk, the condition will determine the financial exposure for you to have restoration done. Is it worth what it could cost? Part of this assessment is to evaluate whether a painting has already been restored and the

amount of repair that has been done.

Black light inspection will allow you to make a general analysis of the location and extent of inpainting. Often, a signature can be seen with black light inspection when it is not delineated by visual examination with ambient light. Also, if a signature has been altered or reinforced, black light inspection will allow a more accurate evaluation of what has been done. In fact, I would advise you never to spend significant money (your idea of significant is a personal determination) for a painting until you have inspected it by black light.

The magnifying glass has multiple uses.Without a raking light inspection, it is often difficult to determine the severity of crackle (or *crackleur*) that is an expected process of aging of an oil composition. If the edges of the crackle are widely separated and the pigment layer has turned or curled at the boundary, extensive conservation methods may be required to stabilize the surface to prevent flaking and paint loss. A magnifying glass will allow a more accurate visual inspection of the edges and the depth of the crackleur. Signatures, inscriptions, dates, and titles can also be discovered or uncovered to greater advantage using a magnifying glass.

The general condition of a canvas can also be evaluated by a careful inspection of the edges. Removal of a painting from its frame will enable you to examine the edge to determine friability for the support and, if an oil on canvas, often determine whether a reline will be necessary. Paintings are fitted into frames by all manner of devices; therefore, for removal of the image without undue trauma, a multipurpose knife with its several functions is an absolute necessity. Nail clippers and files, ballpoint pens, tie clasps, etc. have met with very mixed results. Once out of the frame or away from the glass covering, your inspection process becomes infinitely more precise.

Value is obviously a subjective determination, with many components and parameters affecting this judgement. In general, the most important is the identity of the artist and the painter's standing in the art world. Despite the fact that you have specialized as a collector, it would be exceedingly naive to believe that you know the names of more than a select few artists. I would venture a guess that 95% of collectors of American impressionism could not identify all members of "The Ten." Having intimate knowledge of the training, exhibition record, honors, and awards of a large body of artists would exceed the storage capacity of any human brain.

A reference text will greatly improve your opportunity to identify an undiscovered "treasure." I might add, however, that the reference text should be used only if you have already become interested in the painting on aesthetic grounds. You should collect first for your own pleasure, and these artists are listed because they painted collectible works, but not all of their productivity

has merit. The paintings must reflect the characteristics that placed the artist in the book. Do not purchase the work if you are not emotionally or visually attracted to it, or you may end up as an "autograph collector" with poor and nonrepresentative examples of well-listed artists. Do not relegate yourself to being nothing more than an autograph acquirer.

The pursuit of paintings brings to mind a number of analogies regarding the tools you will need. One would not anticipate a round of golf without a putter, sport fishing without lures, or hunting without the presence of a rifle, bow, or shotgun. Also, you want to know the characteristics of your quarry and where they are likely to be found. These are the instruments of those particular quests. The black light, the multipurpose knife, the magnifying glass, and the artists' reference book are the tools of the art collector. If you want to engage in the described analysis in relative secrecy, store your gear in a camera bag and find a secluded corner in the "facilities." The seller may be so impressed with your approach that they might actually let you decide upon the price — what a wonderful prospect.

7
Frames

Paintings are commonly viewed as merely the distribution of pigment on the image layer. While for descriptive purposes we can certainly regard portraits, still lifes, landscapes, or even pictures of cows as paintings, we should be mindful of the entirety of the composition. This judgement should include the frame as an inherent part of the evaluation process. Frames are, indeed, an art form unto themselves and one that has not been properly appreciated by either acquirers or sellers.

In recent years there have been several exhibitions of important, custom made frames and at least one excellent monograph on the subject. These important attempts have done little to raise the awareness of the intrinsic value of the frame in the mind of most collectors. At some conceptual level (perhaps in the subconscious next to the appreciation for escargot or Baked Alaska) we are aware of the aesthetic improvement provided by a complementary frame, but usually do not carry this judgement very far intellectually and do not properly regard its implications to the value and quality of the whole.

Among the compelling features of Old Master paintings are the truly extraordinary frames that are a part of those compositions. They are often intricate works of craftsmanship rivaling the pictorial content of the painting. Some may represent architectural refinements in their own right. Certain artists of the 19th century were as famous for their frame design as for their ability to create paintings, Herman Dudley Murphy and Charles (brother of Maurice) Pendergast for example. If you have a painting in a documented Murphy frame, the whole becomes significantly more valuable. As a great proponent of appreciation of the frame's contribution, I have often purchased an undistinguished work (at a very modest price) merely to acquire its more important and valuable frame. In fact, it was only a few years ago you might acquire an excellent antique frame in this manner, for only several hundred dollars at an auction. This is no longer true but period frames still remain undervalued.

Certain companies in the 19th century had an enterprising and successful business making custom frames for artists, museums, galleries, and even important collectors. These are well documented by a recent monograph on this subject. Reproductions of these classic styles have become available from

a number of frame companies. The traditional frame moulds and patterns, if patented, have been acquired by newer companies, making them available to you as well. If your dealers frame their inventory with these frames, you will pay cost plus a markup when you acquire the painting. While not inexpensive, the value added to the composite of frame and painting will often justify your expenditure.

Occasionally a seller will describe a "Stanford White" or "Whistler" frame to provide specific identity to a particular pattern. Stanford White was better known as an architect and J.A.M. Whistler as an artist, but each made a significant contribution to the design of frames. More generic terms for frames may reflect the contemporary architectural fashion of the time such as an "arts and crafts" frame. Pinning a proper appellation on a frame achieves at least one significant end — it increases the importance of the frame as an element of the composition and the value will be increased commensurably.

I would offer a caveat should you become too enthralled with the acquisition of important frames. Your painting should properly fit the frame or the stretcher can be easily modified to do so. There are standard sized stretchers (12 x 16, 16 x 20, 20 x 24, 24 x 30, 30 x 36...) and you will eventually find a painting for a frame of these dimensions. If the size of the frame is not standard, you might reduce its dimensions by a bit of cosmetic surgery. Certain frames because of their corner design, or for other structural reasons, cannot be "cut down." Most lovers of frames have a collection stored in the attic, basement, or under the bed as a testament to either their resolve or bad judgement, depending upon your bias.

I would add a note of enthusiasm about the repair of frames and have been quite impressed with what can be achieved in this regard. If you enjoy "healing," the satisfaction can be enormous. Simple toning of the color of a frame will often improve its contribution to the aesthetics of the composition. Even the simple cleaning and waxing of a frame may dramatically improve its appearance and its contribution to the whole visual image. Molded corners can be reproduced using the intact corners of the frame as a template. This often can make a somewhat damaged corner appear intact. Do not re-gild a frame until you have considered whether or not the original gilt may be intact under a dull layer of varnish or, heaven forbid, "radiator" paint. Reapplying gilt, however, is not so expensive as most collectors believe.

Sometimes dealers, in an effort to give what they believe is a fresh or more impressive appearance to a painting, will discard the original frame and add one that appears brighter and they believe more enhancing. Often a liner will be added as well. Despite all good intentions and even if it results in an improved image, I lament the lost opportunity to have brought the entire work back to its original state (appearance). Another advantage of the original frame

is that the exhibition labels are often attached there. Even more interesting might be a note by the artist in their own hand. Antique frames are not for everyone and obviating this sequence of events to replace the old is probably quite acceptable to most collectors.

Frames are part of the composite. Examine the frames in museums, learn the classic period designs. The legacy of the American frame maker is a testament to our native craftsmanship and I believe that appropriate homage should be given to this art form. The next time you consider an acquisition, factor in the contribution or potential contribution of the frame, it may be the package in which the artist's "gift" to you is wrapped.

42

8

Sources of Paintings

By this time, you have visited museums, discussed your preferences with other collectors, and familiarized yourself with various major periods or movements of art. This will then provide structure to your quest for acquisitions. The mode of acquisition and the type of painting will determine which form of knowledge or what information you should have. In understanding the process, you can make informed choices and feel truly a part of the endeavor. Research in art collecting should be as systemized as research for any important transaction. If you were purchasing an automobile or even a toaster, you would do some research to protect yourself against an unwise choice. This should be as organized an accumulation of data as possible. You have an infinite variety of choices as to where you may acquire paintings. Irrespective of the source, knowledge on your part is paramount to any assurance of success. Know what you need to know.

As noted previously, I would recommend that you seek the advice of a reputable dealer specializing in your area of artistic interest. The major art centers will have a number of dealers specializing in the paintings you are most likely to collect. From each, something can be learned and an in-depth look at their inventory will greatly improve your general knowledge and perspective. The first objective of the dealer will be to impress upon you that their inventory consists of major examples in absolutely pristine condition, and that their presentation of the paintings is important to create the aura. Unquestionably, dealers have selected as many good paintings as they can, but they are also biased in their choices and may have something in "the racks" (gallery storage) or in remote storage, that you would find particularly appealing.

After the perfunctory tour through the paintings they have on display on the gallery walls, you might ask them about the remainder of their inventory. In some ways this will be a more intimate viewing of the paintings that they have for sale. "Running the racks" may not occur with your first visit to the gallery and you should not anticipate that it will. If you manifest interest and knowledge over time, you will be allowed to view the entire offerings of the gallery. Gaining entry may be part of the learning challenge that will stimulate you to become a more knowledgeable collector. Remember the dealer, for various reasons, may have paintings that they do not consider particularly

desirable and you will not ordinarily get to see these. You have to gain the trust of the dealer and they have to be comfortable with what you are trying to achieve.

Dealers have a limitation in their ability to research every painting in their inventory, providing you with the opportunity to make a contribution to the research process. You will know you have arrived when the dealer, showing genuine interest in your assessment, asks your opinion of a painting. Gaining the respect of a knowledgable dealer is a rewarding process and from this relationship, you may be assured of a continuous supply of good quality offerings. Your dealer has many sources of inventory not readily available to you and will use their expertise to select the most desirable examples in the best condition for your consideration. The reputable, informed dealer should be an essential part of your quality control and selection process, and a primary source of paintings for you.

The next most important source of paintings are the auction houses. Here you are more on your own and independent research is an absolute necessity. Just as one becomes personally familiar with knowledgeable and experienced dealers, one should become well acquainted with the staff of the auction house. The success of an auction house depends upon their reputation, which is based primarily upon the quality of the offerings and the manner in which the staff interacts with their clients. Part of this reputation is also based upon the knowledge they make available to their potential bidders regarding the works to be auctioned. As collectors have come to understand the importance of condition, auction houses have made the condition information increasingly more detailed. In fact, the condition reports provided and discussed by the auction house staff are often more informative than the opinions of a private dealer. However, the dealer offers the collector greater recourse after pur-chase, with more opportunity to arrive at a satisfying agreement. With the auction house, it is largely *caveat emptor*, so do your research before you bid.

Estate sales are very different from auctions as the merchandise is mixed and varied. Paintings, glass, furniture... may be auctioned in no particular pattern. To save time, if the sequence of offerings is not known, you should request of the auctioneer that the item you want to bid on be offered when it is convenient for you. Sometimes the auctioneer will group items by category (paintings, pottery...) so as to insure that there will be an adequate number of bidders in the audience. Thus, all the paintings may be sold at one time.

Tag sales generally fall under the rubric of estate sales. With these you can make the seller an offer if you think the tag price is too high. As with estimates in auction catalogues, the expected prices can be indicated, but that does not preclude a reasonable (in your opinion) offer. Do not feel that you should be timid in exploring the real selling price of an item. Not only may your offer be

deemed reasonable, but it may be accepted. Tag and estate sales are not as efficient as auctions dedicated to an inventory of paintings, but the opportunity to acquire a bargain is the often inescapable allure that attracts collectors. This is a source, but an unpredictable one.

The most overlooked and often one of the most appropriate sources of paintings are other collectors. Collectors generally refine their tastes and may even redefine their proclivities. Thus, they will occasionally wish to de-access certain paintings. Collectors also acquire more examples of a particular artist or a particular subject or aesthetic than they eventually want to possess. I did this with nocturnes and Barbizon paintings, for example.

Fellow collectors become vulnerable before and after an exhibition. As the collector feels compelled to add a painting just prior to an exhibition, they may feel just as predisposed to de-access it immediately after the exhibition is complete. This was my own experience after an exhibit on portraiture. Where do you display six 70" x 40" portraits, however appealing and important they might be? After all, 25 examples of women in kimonos or 45 tonalist landscapes can become monotonous if viewed together over a long period of time, and for some of us — instantly.

Your exchange may even involve a trade among colleagues with the paintings acting as resources "in kind." Each of you will value their painting and the transaction functions by the rules and practices of the old fashioned barter system. This can lead to a mutually beneficial exchange. For example, you may desperately need a genre painting of a certain period for an exhibit, and own dozens of painterly landscapes. Your available landscapes may allow you to acquire the example you needed but could not afford, or would not be offered for loan, except in the circumstance of a trade. One of the real benefits of interactions with other collectors is the shared knowledge and friendships that develop as a result of the interchange. Some of my most poignant memories of art have been my interactions with fellow collectors and yours can be also. They often become cherished friends.

The heirs or relatives of artists may represent a source of paintings. Locating them may require a bit of research, but several techniques have proven fruitful for me. Other collectors may tell you of the existence of these relatives and their whereabouts and occasionally a dealer will make an introduction. Tax and probate records are a valuable source of information in locating these people. Probate records which are in the public domain will often allow you to identify heirs who do not have the same surname as the artist. The telephone book will reveal the appropriate relatives if you have the artist's surname. I have uncovered estates by searching public records of various types. Your effort and persistence can reward you with the opportunity to see fifty or even several hundred works by a particular artist, truly a singular collecting

experience. You do not have to be Clarence Darrow, Melvin Belli, or Johnny Cochran to gain access to the archives. Just look reasonable and have some identification, but be prepared to commit the time.

De-accessions from museums were in the past a reasonable source to acquire paintings privately. However, the revelations that these practices were abused have made the governance bodies of these institutions so circumspect that these de-accessions now occur mainly by public auction. These transactions have to occur at "arm's length," utilizing the free market system supposedly to establish their true value.

From this discussion, it is apparent that a variety of sources of paintings are available to you as a collector. Each should be recognized and employed to fit your particular acquisition needs. Use them all and search out antique shops and malls as well. Just know what data you need to assess the risk you are taking, and determine the resources you are willing to commit to the uncertainties. If you have a chance to acquire what you believe is a small Martin Johnson Heade worth $60,000 for $800, do so; but if you think you can have a $3,000 Ben Foster for $2,000, then the risk to benefit ratio is not so compelling. Remember where the safeguards and assurances are in the system and collect from the various sources accordingly.

9

Acquire at Auction

When retail prices appear beyond your reach, an alternative may be to acquire paintings at auction. This avenue, however, should not be taken by the uninformed, the unwary, or the faint of heart. To be successful, you must apply the appropriate scholarship, spend the requisite time in evaluating the paintings, and exercise self-discipline on the auction floor.

Knowledge is the best insurance you can have. Catalogues and post-sale price lists are excellent data sources to prepare yourself for auction. Study these over a period of months to several years, which is much like charting stocks, before you attempt to acquire at auction. I recommend you order a catalogue prior to the sale and after serious analysis determine what you would pay for those paintings that you would be interested in and write that figure down. From the post-auction price list, compare your prediction or theoretical offering price with what the painting realized at the sale. If your prediction was not in close agreement with what the painting brought, try to determine the reason for this disparity. Learn more about the artist and the particular piece, ask knowledgable dealers and fellow collectors for their opinion.

When you are sufficiently "informed" and experienced to begin your career as an auction bidder, there are several disciplined activities that you should follow. After receiving an auction catalogue, go through it several times to determine which paintings interest you most. Plan to visit during the auction exhibition and arrange to go through the paintings you are interested in with one of the staff to discuss the merits of the paintings, their histories and, most importantly, the condition reports.

You should examine carefully the back of the painting. In addition to being able to evaluate the condition, you may discover labels that can reveal much about the provenance of the work. Artists often inscribe interesting data about the painting there, such as the time and place it was executed or the title they gave to the painting.

The leading auction firms are usually candid and critical in their evaluation of paintings, especially with collectors they know to be very demanding (like I am told I am). Ask for the proverbial "black light" examination, especially if the appearance of the painting does not match the condition report given to

you by the staff. If a painting is in poor condition and will require significant restoration (including inpainting), avoid it unless you feel confident about the expense it will involve as well as the outcome of the restoration. The types of paintings everyone searches for are the pristine ones that have not had any "work" but reflect the fact that they have passed through life in an environment which allowed the support and pigment layer to age gracefully.

Along with the condition, you will want to determine what support the painting is applied to. Rigid supports, such as paper or canvas mounted on board, masonite, or aluminum, present inherent difficulties in future restoration or conservation. Therefore, paintings mounted in such a manner should be in very good condition if you plan to buy them at auction or by any other mode of acquisition for that matter. Aluminum, for example, is often covered by canvas, even covered in the rear, and the novice would neither see it nor recognize the feel of it. Paintings mounted on masonite are very difficult (and expensive) to restore.

It is important to know where the inventory offered at auctions comes from, and this information should be taken into consideration. Ask for the provenance. They may not tell you specifically the consignor but will indicate if it is or is not a private party. The paintings you should most actively seek are those from private holdings which are reaching the open market for the first time. Dealers will also bid very aggressively for these "fresh" paintings.

Private consignors such as collectors vary greatly in their reasons for de-accession so you are best guided by the consignor's understanding with the auction gallery staff. This is much more rewarding than attempting to deduce by Jungian logic the consignor's frame of mind. The auction house wishes to make a sale, usually knows what the painting is actually worth, and wants a satisfactory transaction for both parties. They are really on both sides but legally represent the consignor at this point.

De-accessions from museums can be a source of good and desirable paintings and usually have a definitive provenance. Museums may de-access a painting because they have other examples by that same artist or it does not fit their current statement or image they wish to convey. Often, museums will set a modest reserve because they genuinely want to de-access the work and do not want it to be a "buy in." Remember they have to go through a screening process, which is often arduous, to be allowed to offer the work publicly. Museums are often anxious to complete a de-accession because of the difficulty they encounter receiving approval from their board before the sale to even offer the work to the public. Also, their cost basis is often low as the painting may well have been a donation to them; and they often de-access paintings because of legitimate space and exhibition theme considerations. For museums, taking a painting back is a complicated procedure and one they

go to great lengths to avoid.

Private galleries generally consign two types of paintings, those they cannot sell for various reasons or "blockbuster" paintings they believe will fetch "super retail" prices at auction. The latter are a fairly recent phenomenon, but the dealer's expectations for those paintings will usually mean that you have little chance to acquire them after the sale. The dealer will let them "bid in" to await another day.

Galleries sometimes dump paintings at auction which they are having difficulty selling. These are generally referred to as "trade paintings". "Trade paintings" (those that have been passed around among galleries or have been in many previous auctions) should be avoided because there is often a very good reason they have repeatedly changed hands among knowledgeable owners. I avoid these paintings because among other things, they are quite problematical for exhibitions, illustrations, or later de-accessions. In my experience, they are often poor or nonrepresentative examples by famous artists appearing dark and dull. Unless you are an "autograph collector," you should avoid these examples because they will not wear well as part of your permanent collection and upon resale, they will typically not increase in value. The fact that a dealer cannot sell a painting may not always condemn the work. Most dealers have a specific clientele and may specialize in a particular period, subject matter, group of artists, or those from a specific region. The piece they consign may represent none of these criteria, so they arrange for a quick de-accession at auction. Again, what you wish to avoid is a "shopped" painting; one that has been around the trade and is "tainted" by this history.

Because of the temptation to own impressive titles, inexperienced collectors will acquire unattractive examples because they are perceived as "bargains." Try to avoid this practice. If you do succumb, do not be too distraught, most of America's great collectors engaged in this bit of folly early in their careers. After all, everyone is searching for a bargain, but an undesirable painting acquired cheaply is never a bargain. They only serve to emphasize your naivete and inexperience to any sophisticated audience, such as a fellow collector, gallery owner, colleague, art historian, or museum curator whose approval you might like to have.

Unless you have unlimited funds — in some ways, an unfortunate circumstance — you must recognize that there may be certain artists whose representative examples are beyond your resources. Rather than buy a work with little aesthetic appeal and without the painterly qualities that made that particular artist famous and desirable, simply pass. Early in my career I purchased at auction a very nonrepresentative Julian Alden Weir as a "bargain." After several years of attempting to convince myself that this landscape was an acceptable example for my collection, I consigned it to

auction. This de-accession proved the P.T. Barnum theory by unexpectedly producing a sizeable profit in the transaction. Later, through a conservator friend, I was able to acquire a good example of Weir's artistry. I wanted a Weir because he is an excellent artist and an important figure in American Impressionism, but I first bought a minor and undesirable example — an error even though I gained financially. Good examples of Weir are expensive and I could not afford to acquire one at retail. Thus, I should not have acquired a Weir at all unless I acquired a representative one in a special circumstance, and eventually I was fortunate enough to do so.

A reasonable alternative for an expensive artist, is a good drawing or a work in a non-characteristic medium (pen-and-ink, pastel, watercolor, or mixed media, depending upon the artist) which may be affordable, can be appealing, and will demonstrate their desirable technical qualities. After purchasing several poor but genuine examples of the work of Edmund Tarbell, I finally acquired a wonderful pastel of the artist's sister-in-law Lydia. Several years ago when the painting was loaned to the United States Embassy in Paris, it became very clear to me how attached I was to the work because it is aesthetically lovely, demonstrates the best qualities of the artist and was his sister-in-law.

Many of "The Ten" and "The Eight" command auction prices equal to or greater than those works by these artists acquired privately or in any other manner. If the examples of these artists are excellent or the paintings are by some of the "rarer" members of these groups, dealers are willing to pay even more than the average collector so that the dealer will have an example in their inventory. A dealer may also be acting at auction as an agent for a serious and well-funded collector (and they are not all Japanese industrialists). I would recommend searching the auction catalogues to find great examples by the students of the leaders of "The Ten" or "The Eight" or from the school they represent, such as the Art Students' League or the Boston Museum of Fine Arts School. This idea will be expanded in my discussion of the regional artists.

Great examples by lesser-known artists, I believe, are good values. At auction you will often be able to compete more successfully for a major Gretchen Rogers or Ellen Day Hale than a minor example of the work of Frank Weston Benson or Joseph R. DeCamp all from the Boston Museum School. Most of the bidders will have never heard of Charles Wright but would "run the table" for an unfinished (and unappealing) William Merrit Chase, his teacher. I selected Wright because I purchased one that was similar in subject and composition to a Shinnecock example by Chase (which is in the Cleveland Museum). My painting was recently selected for an exhibition of Chase's students by Ron Pisano, the William Merritt Chase scholar.

When you view a pre-sale exhibition and see an appealing painting by an unknown artist, a few minutes research in one of the dictionaries or reference texts might reveal that the artist trained in Paris with Theodore Robinson or painted in Old Lyme with Childe Hassam. You may also find that the artist had several one-person shows or a retrospective exhibition with a brochure. A few hours in a reference library will sometimes be rewarded by a catalogue with illustrations of the entire spectrum of the artist's work. Several times I have had the good fortune to find that the auction piece had been represented in an exhibition brochure, allowing documentation of public exposure and comparison of the painting with other examples by that artist. You can then judge whether or not you are acquiring an outstanding example of the artist's work. You may not choose to spend your time in this manner, so remember, your time is yours as are your other resources.

You should also know your competition as well as the origin of painting. Speculators will buy paintings on the presumption that they will fetch higher prices as private resales or at future auctions.

I believe that the effect of foreign investors on the prices of American paintings has been overemphasized. Admittedly, the Japanese, for example, seem to have had unlimited funds and an insatiable desire for the most major examples of impressionism and post-impressionism. However, for the majority of collectible American paintings, there appears to be little competition from foreign investors. The unbridled enthusiasm for the most important American paintings by the Japanese and Europeans did momentarily have implications for auction prices because the frame of reference for other works of similar style and subject matter became momentarily distorted in the mid-1980s.

There are those who reason that certain types of paintings remain undervalued because their equivalents from other countries bring much higher prices. These observers compare the prices achieved at auction by the French versus American impressionism. They reason that great examples of the impressionist aesthetic by American artists will eventually sell for millions and representative works by these master American impressionists will someday routinely bring hundreds of thousands of dollars just as the French do at present. Although I do not believe American impressionism to be a totally derivative art form, I do not feel this painting style executed by Americans will ever reach the financial numbers achieved by Monet, Van Gogh, and their contemporaries. The value of paintings by American impressionists should increase with time but may very well not exceed that of growth stocks, money instruments, real estate, or commodities. While you might consider investments other than stocks and conventional money instruments, keep in mind art is generally not liquid and sometimes requires special knowledge to de-access effectively.

The financial climate has changed in the last decade. October 1987 and certain tax changes made many investors wary, nervous, and much more conservative. Bond yields have been described as boring, and tax laws have made real estate ventures much less popular than before. Commodities are too risky for most investors, and the IRS has chosen to tax gains in this instrument as they occur rather than after they are realized. Given this environment, it is quite understandable that among the buyers of paintings there are participants that can only be characterized as investors and speculators and not collectors. Some of these acquirers have little knowledge about the painting they are buying or art in general. This commitment by them is regarded solely as an investment. Collect paintings for aesthetic pleasure and leave the profit motive for other activities. Can you make money with art? Absolutely. I only suggest to you that it not be your major consideration or a means to an end.

A number of young people have made a great deal of money in the past several years. They see an art collection as a symbol of wealth and are active and very aggressive in their acquisitions. These new collectors do not have the benefit of history of prices for a particular artist and initially have little knowledge or experience in evaluating the condition or aesthetic value of a painting. Thus, they are more inclined to overpay at auction for a painting by a known artist or unwittingly for a painting that is in poor condition than the "pros" who are resting on the sidelines. Having never had a painting restored, these collectors cannot be expected to accurately calculate or in truth anticipate the cost of the restoration in addition to the purchase price. They usually remain uninformed because their motives are not to learn about art but to use it for symbolic purposes instead. Just identify these lemmings but do not follow them.

Although I have no hard and fast data, I believe that dealers are increasingly executing bids in behalf of their collectors. Thus, you can no longer feel comfortable with the fact that a painting is selling to the dealer at a "wholesale" price. Do not assume that the dealer is acquiring the painting for inventory and, therefore, must purchase the painting for a price so that the work can be later sold in their gallery for at least a profit. Instead the dealer may be acquiring the work for a collector, investors, or speculators who have instructed them to purchase the painting almost irrespective of the bidding price. In the 1990s there appears to be less speculation in the art world than in he 1980s, but it is still significant.

So-called "blockbuster" paintings with great visual appeal and uncomplicated subject matter will usually sell for premium prices at auction (they win the beauty contest). For example, painterly landscapes containing human figures composed in light, bright pigments will generally fetch high prices and attract many interested bidders. Dealers appear to believe that they can pass

on to their buyers any increased costs at auction associated with the acquisition of this type of painting. As a private collector, you might adopt the same attitude, but most of us would like to think we were receiving at least "present value" for our financial commitment at the time of purchase.

What has all of this to do with auction acquisitions? Everything because it sets the environment and parameters.

After previewing the auction, make a list of the paintings you like and decide, on an individual basis, how much you would commit for each; then prioritize your selections. The multiple considerations of auction prices for paintings may not provide a clear mandate for any particular course of action. However, it is a time that you must decide within yourself the value of any particular work to you. You should then offer this at auction in whatever manner you feel most comfortable with.

Everyone has a personal conviction about what constitutes an appropriate allocation of resources for their art collection. It is also personal what you believe represents a suitable expenditure for an individual painting. In this consideration, you should calculate the additional expense for conservation, restoration, or re-framing, if this is going to be necessary. These costs vary but are real, and a pre-sale determination of these costs may be a prudent investment of your time. I once bought two painterly and wonderful female figure studies (70" x 40") by Raymond Rogers Perry Neilsen but had not estimated the cost of restoration or re-framing. To meet these estimated costs, I sold one painting to a dealer. Several years later I decided to reacquire that painting and after some independent research found it in the Ralph Lauren mansion (shop) on Madison Avenue. Since I thought it might make an interesting addition to my other Neilson, I talked with the manager who was very understanding and said that the painting was "not for sale" but revealed to me their purchase price, which was more than 20 times my acquisition cost. You must go see it sometime at the entrance of the mansion on Madison Avenue in New York!

Once I acquired at auction a very large early Sanford Robinson Gifford that had been de-accessed by a famous museum of American art. The painting was very well documented and had been exhibited, but it demonstrated such detractions as significant crackleur, "yellowed" varnish, and a damaged frame. Radiographic studies and consultation with a conservator that I respected confirmed that the work was structurally sound and would require little or possibly no inpainting after it was relined. Thus, once restored, the painting could very well represent the genius of one of the great members of the Hudson River School. I purchased the work and, after restoration and suitable framing in a period reproduction frame, I ended up with a major example for less than one-tenth its current appraisal value. The painting has

been on exhibition and holds up well alongside the Thomas Coles and Asher B. Durands in the same forum. In this instance, auction probably afforded me an opportunity to acquire a painting that I could not have purchased as inexpensively by any other method.

You have several options of bidding in acquiring by auction. The absentee bid form is the most passive route but the one with the greatest risk, because you have the potential and possibility of acquiring *all* of your selections. One safeguard is to select only one or two pieces to bid on. Another is to be overly conservative in your bid on each painting, so your only chance of being successful is if one painting were to sell at an unrealistically low price. If this happens, you should be concerned that you missed something in your evaluation and appraisal. Alternatively, you can have someone act as your agent during the sale for a fee. With proper instructions to your representative, you can avoid unwanted multiple acquisitions.

Another technique of acquisition at auction is the telephone bid. This has to be well organized and orchestrated, and a service that is not available from all auction houses or for all the sales of any. If available, this is not as complicated as most collectors believe. The staff person will phone you at a pre-established time. Keep in mind that during the bidding process you will have a sense of isolation, because you have no *prima facae* or personal information as to what is going on with the other phone bidders or on the floor of the auction house. Telephone bidding requires discipline and even some imagery to maintain your frame of reference to properly guide your instantaneous judgement. I again emphasize that you should never bid on a painting until you have personally examined it. Even appointed factors or designated bidders, used by some collectors, should be carefully selected and specifically instructed before they act in your behalf.

Promise me you will never acquire a painting unless you have held it in your hands and visually inspected it. Photographs in sales brochures and auction catalogues are so clear and sharp, as well as having brilliant color contrast, that they may have more eye appeal than the actual painting itself. I have been at auctions and watched phone bidders drive the price of a dull, lifeless painting beyond anything reasonable. I also noted that the appearance of the painting in the auction catalogue was much more attractive than viewing it in person. I am certain the "successful" bidder was very disappointed when they actually held their purchase.

The preferable method of acquisition, and the one which offers the greatest control and least risk to you, is to attend the auction in person. The only real danger is the disorientation which occurs when you get caught up in the competition of the chase. To always exercise discipline is difficult in this exciting arena. I have a practice to maintain my frame of reference which may

be helpful to you. Write down your highest bid in the catalogue before the sale and simply do not exceed that figure. Other tactics can be effective, but the usual ones of secretive bidding or sitting or standing in the back of the room to determine who is participating often do not make any significant difference in acquiring paintings at auctions. Sometimes you can attempt to intimidate a competing bidder by jumping the bidding increments. For example, if bids have been at $250 increments, raise the next bid $500 if you can do so, and still remain within your pre-sale limit. Appear to have the resolve to acquire the painting irrespective of the price (I emphasize *appear*). Otherwise, the last paddle down is the "winner," and the competition may think that only one more bid by them will take you out of the bidding.

Discipline comes from within — forget about winning and losing; this is not a tennis match, a hand of bridge, or a round of golf. When the bidding is escalating rapidly, it is important not to enter until the fervor levels off. Try to bid so that you will have the last bid just prior to a major increment ($9,750 just before $10,000, for example). Having someone bid for you at auction only makes sense if they can position themselves on the "right" side of the bid and you cannot. If your maximum intended investment for a painting is $50,000 and the bidding is in $5,000 increments, you will want to be holding the $40,000 bid. Also, do not forget that at $50,000 you have spent $55,000 (10% for fees and premium) prior to shipping and insurance.

You should also have a current idea of your expenditure at the auction from moment to moment and bid accordingly on the next painting offered. This I call the "exposure" determination. You really do not need someone to do the math for you, but do it ahead of time; it is your road map. When you are present at the auction, you should be in control of these factors, but only within the limits of your self discipline and contained grace under fire. It's what Adam did after he saw the apple that got him in trouble.

In a rather fast-paced world, many collectors have limited time to consider their acquisitions. The preview of auctions may be hurried and cursory, the gallery staff available for only a short period of time, and the number of paintings under consideration almost overwhelming. Thus, a post-sale trans-action may well represent a more studied method of acquisition. This little appreciated method of purchasing art, *very* selectively purchasing "buy-ins" or "passed" works after the auction, is quite viable in this context. Most collectors are either unaware of the post-auction process or do not understand it. They also may feel a bit intimidated by dealing "one-on-one" with the auction gallery staff and through them with the consignor of the painting. You can expect the auction gallery staff to be helpful and discreet. After all, they are probably dealing with a disappointed consignor and a situation in which the process has not been successful. Auction houses make great efforts to

avoid having paintings repeatedly offered by them or by rival auction houses, as they become "trade pieces" that have been declared used goods.

This little-known method of acquisition offers interesting possibilities. Conventional wisdom fosters the idea that unsold paintings are not good ones and are thus not suitable for collectors to acquire. These works may have condition problems, represent poor examples of the artist's work, are "too dark," "too stiff," or of questionable authenticity. Each of these circumstances represents valid reasons for the "did not sell," and if these reasons exist, then you should not attempt a post-sale purchase of these paintings. The same criteria of quality should be employed as with any other method of acquisition. If, however, a painting did not sell because the pre-sale estimate was unrealistic, the reserve was too high, the painting was too large for most collectors, or the subject matter does not have general appeal, then the painting may well be a potentially desirable one for you.

Another deterrent is the incorrect assumption that the price they should offer is the highest bid that was achieved on the floor. Often your price of acquisition can be reasonable as the "high but unsuccessful bidder" during the auction is no longer part of the process. Actually the only relevance the auction bid has to the post-sale transaction is that it may influence the expectations of the consignor. If the figure achieved at auction is far below the reserve, the consignor may become much more flexible and accept a lower post-sale offer from you. Thus, you should offer initially what you feel comfortable with in acquiring the work. If this is not accepted by the consignor, you can always increase the offer or discontinue the negotiation. A counteroffer may often reveal the true expectations of the consignor. Also, if the staff of the auction house feels your offer represents fair market value, they may indicate this to the consignor.

High estimates in the pre-sale catalogue sometimes discourage potential bidders to the point they simply do not enter the process. High reserves (usually above 80% of the low estimates) may create the illusion that a painting has sold at the auction when it, indeed, has not. Large paintings even of museum quality may not be practical for most collectors or dealers, but you may have a specific collection or space in which they will fit nicely.

Whether a particular subject is appealing to you or fits your collection is a personal consideration. For example, I have a penchant for nocturnes which seem to have limited appeal to the general collecting public, J.A.M. Whistler notwithstanding. Because of this contrarian logic, I have been able to purchase at auction outstanding nocturnes by recognized artists such as Robert Henri, Edward W. Redfield, Leon Dabo, and George E. Browne for very reasonable sums. These form my nocturne and tonalism collection that has been the subject of a traveling exhibition and monograph.

Auctions are a reasonable forum for you to acquire paintings if you follow at least some of these suggestions. They are also interesting if you enjoy "people watching" and like to observe dynamic, emotional phenomena. On the one hand you just might be rewarded with a bargain for your independent scholarship and if you follow my guidelines you probably will avoid paying too much or acquiring a painting you will never enjoy.

I hope this discourse has not created the idea that purchase at auction is unduly risky or complex. While not attempting to be encyclopedic, I have endeavored to sufficiently emphasize the importance of appropriate preparation and due diligence before acquiring art in this manner. Do not expect to "get lucky" or to stumble into a great acquisition. Many of your competitors will also have approached this process in a scholarly, disciplined manner, significantly diminishing the element of chance. Knowledge is the substance upon which prudent acquisitions at auction are based. Discipline and organization are the techniques that provide the foundation for the successful collector.

Depending upon your assessment of your personal self-discipline, you may wish to avoid the open competition and "hype" associated with the auction itself. Never depend upon intuition in this instance — you are engaged in a serious activity and it involves money, not pride and honor.

10
Collectibles: A True Investment

The media is replete with accounts of the enormous prices paid for objects of art and collectibles. At no time in our social evolution has status been more explicitly conveyed by your possessions. Conventional wisdom regarding collections of all types is that if one acquires quality in the individual objects they will increase in value and may outstrip other types of investments in growth potential. Obviously I cannot generalize upon all types of collectibles as there are certain specific trends that would not be taken into account. I have, however, considered several common categories that have current vogue: American impressionist paintings, waterfowl decoys, and antique and semi-antique oriental rugs. These also have been discussed in many articles as sound investment vehicles. While the value of a well-chosen collection will grow, it is illiquid, and from a strictly commercial sense you would be better advised to allocate your funds designated for growth in more traditional financial vehicles. My advice is to collect these objects for their intrinsic merit, the pleasure of ownership and the research and scholarship associated with acquisition.

American paintings have been highly collected both for their aesthetic appeal and historical importance. The Old Masters works have had a rather continuous following for most of the 20th century. Various movements have enjoyed a momentary popularity and subsequent decline. Most interesting to you may be the American impressionists, luminists, tonalists, and those artists practicing the Barbizon aesthetic.

One of the more remarkable phenomena of 20th century collecting has been the fate of paintings reflecting American impressionism. Although achieving contemporary acceptance in the 1890-1910 era, impressionism became passe with the emergence of the Ashcan School and the various phenomena I call "isms." In the 1960s there were few active collectors of American impressionism, and they were able to acquire major examples of the most famous artists at quite reasonable prices. Impressionists such as William Merritt Chase, Childe Hassam, Edmund Tarbell, and Frank Benson were available but at acquisition costs in the $25-75,000 range. In the mid-1970s, however, a number of exhibitions and texts demonstrating the technical skill and quality of the American impressionists began to create such a demand that represen-

tative examples of these leaders (such as "The Ten") began to creep into six figures.

I can remember in the early 1980s watching a famous New York gallery pay more than $500,000 for a Chase pastel and thought this represented a departure from reality. Sometime later a leading dealer from Texas offered me a Robert Reid I had once owned. I paid $3500 for it, changed the varnish and refurbished the frame and, after two to three years, traded it for about $7500 in value on what I felt to be a more important work. When the dealer called me after allowing a week or so to view the transparency, he stated it was in his opinion fairly priced at $115,000. This revelation caused me to begin pricing the American impressionists, and I found that those featured in the texts by Boyle, Hoopes, Gerdts, Pierce, and others were now beyond most collectors' means, but those other artists even mentioned and illustrated in these texts had also increased some five to fifty-fold. All of these were now near or above the $5-15,000 range.

The luminists received incredible exposure with the "American Light" exhibit at the National Gallery in the 1970s. Following this exhibition and the bicentennial celebration, "The Icebergs" by Frederich Church brought more than one million dollars at auction, and the price of representative works by the major artists of the Hudson River School regularly achieve high six figure prices. Most long term collectors observing this phenomenon have formulated the strategy that even the second generation members painting in the luminist style are worthy of consideration, and the free market prices for these works have reflected this decision.

To a lesser extent those artists whose estates were featured by leading dealers have shown substantial increases in value. Although this might be considered a somewhat artificial market and not the free enterprise system operating without intrusion, it was a real phenomenon. Several art historians became dealers and in the 1970s they wrote extensive catalogues, monographs, and small texts about artists in their inventory, creating an active market of newly informed collectors. This made many art dealers predict that one could expect an "across the board" increase in the value of American impressionists. These dealers were criticized and envied, but I thought they were doing something very worthwhile, creating knowledge and awareness of American painting for the American public. You could be fairly certain that this technique would increase the value of these paintings but as a collector, these books allowed you to see the spectrum of the artist's work.

The economic factors that often affect the value of collectibles include alternatives for investments and the purchasing enthusiasm of the public as a reflection of tastes. In the mid-1980s there was some softening of the American art market but not at the upper end; the established artists never

became bargains nor did quality paintings with eye appeal and in good condition by the lesser-known artists. For the decades of the 1970s and 1980s there was a gradual increase in the value of American paintings especially those of the impressionists. There was some retrenchment in the late 1980s, especially at the lower end. The 1990s have seen a slow but definite upward trend. The quest for the great pieces, however, has often been so aggressive that they sometimes command more in the free marketplace of an auction floor than they would bring at a reputable gallery.

If you aspire to acquire an extensive collection of American paintings, you should plan to seek examples of the students of the great masters of your chosen genre and those well-trained but lesser-known artists practicing side by side with their mentors. Otherwise, you may be relegated to collecting minor or nonrepresentative examples of the better-known artists. If you succumb to the latter fate, there will be little quality or aesthetic appeal to your collection and consequently little increase in value.

The Bicentennial Celebration greatly increased interest not just in American impressionism but in Americana. People sought objects of American folk art so aggressively that primitive portraits sold for hundreds of thousands of dollars and no exposed weathervane, if genuine, was safe. The value of waterfowl decoys also increased greatly due to the fact that they represent an indigenous American art form and they are rare. The desire for these decoys increased steadily but slowly for about a decade until 1986 when mania struck; the record of $205,000 in midsummer for a wood duck by Joe Lincoln was quickly replaced by the sum of $319,000 paid at auction for an Elmer Crowell preening pintail. Was this a trend or an aberration, the Wall Street Journal wanted to know? There have been a number of major auctions since that summer and no decoys have fetched more than $200,000, but prices for the good collectible decoys have held nicely and certain types that previously have had little exposure such as Louisiana, Virginia, and North Carolina decoys are increasingly rapidly in value.

Collectibles that serve a utilitarian purpose such as American furniture, to some extent china, crystal and silver, and oriental rugs, probably afford a great measure of safety in wealth retention. American furniture pieces by the known makers have increased astronomically in value as this reflects their rarity. When a tea table commands $1,000,000 at auction and a chair more than $2,000,000, we may be dealing with the same situation as with the major examples of American paintings.

Oriental rugs offer you a collectible that is aesthetically pleasing, serves a functional purpose, and will hold or increase its value over a period of time. "Oriental" rugs are made in many countries, including Romania which hardly qualifies under traditional geography. Many people mistakenly believe that all

Persian orientals are collectible, and this is simply not true. Just because they are handmade or old, they will not necessarily increase in value. In fact most orientals will at best hold their value, but this alone separates them from machine-made carpets and many other objects for use in one's home. In general, one should be attempting to gather choice examples (those in good condition) that are more than 50 years old. I know that a century of age is usually required to designate an "antique," but if you plan to acquire 1890s Persian rugs in good to excellent condition, you should be prepared to spend a substantial amount, probably many thousands for each example. Rugs imported into the U.S. in the 1910s and again in the 1930s are reasonably plentiful, can be found in good condition, and provide a great variety of choice. Persian rugs have been the traditional collectibles and remain so today. They are not, in my opinion, an alternative to paintings, however.

Obviously there are endless categories of collectibles besides paintings. Most of us collect all manner of things mainly for their aesthetic importance to us and not for their potential increase in monetary value. The "take home message" then is to collect what is appealing and items which demonstrate the best qualities of the particular artists you are interested in. They will grow in value but should not really be thought of in terms of percent return on your money as they as an investment may prove to be rather illiquid, and the marketplace for their sale and exchange is limited. Unless part of your collecting and acquisition formula is the sense of pleasure in ownership, reading about the art you have or are about to acquire, visiting galleries, museums and dealers, and getting to know fellow collectors, do something else with your time and money.

11
Funding and Financing:
The Realities

The appropriate resource allocation to your collections depends upon a number of variables and a few imponderables. Collecting is often such an all-consuming passion that many collectors say "commit whatever it takes." My advice is "whatever you can afford."

Remember from our discussion in the last chapter art is not necessarily an "investment" or at least not one from which you should expect a short term profit. Consider the acquisition cost as an alternative resource allocation, rather than as an investment. For example, judge the possible acquisition of a Thomas Moran, Winslow Homer, Childe Hassam, or Jackson Pollock as a percent of your net worth or a certain fraction of your available funds rather than anticipate that the percent value will increase from your allocation over a specified number of years.

"Affordability" of a particular painting depends as much upon your collecting philosophy as it does the actual number of dollars you have available. Paintings are not as perishable as racehorses, but their value can sometimes drop almost as precipitously. Remember, it is a very rare incident when de-accessing a painting happens as rapidly as "unloading" a thousand shares of the XYZ Corporation.

The majority of the time, acquiring a painting is an intellectual exercise, using your *discretionary* funds. Sometimes, it becomes an activity driven almost entirely by emotion and, thus, is difficult to put in financial perspective. Every true collector at some time in their career will be faced with the circumstance that they believe they simply *must* have a particular painting. In this situation, collectors are predisposed to throw caution to the winds and to overextend themselves. As a result, they may later become very defensive if challenged about the purchase and promise themselves "never again..." Do not overextend yourself or you will lose some of the pleasure of the process. This is not always a rational exercise and it may well be your passion, however, never accept that it is your "vice;" a vice is overeating, smoking, substance abuse for which you never receive a pretty achievement.

From purely a business viewpoint, you should not have more than 10-15% of your assets in art. The informed and experienced collector may choose to have more because they are presumably better able to identify a prudent

acquisition and to negotiate a more favorable price. However, anything over 25-30% and you have, whether unwittingly or purposefully, now become an investor/dealer. This level of commitment usually means that at some future time, you will need to divest yourself of some of your art, either to produce exhibition space or to raise funds.

If you read the comments of collectors in the introduction to exhibition catalogues, there will usually be personal stories relating how various dealers may have allowed the collector to pay for the work over time. By the most generous of accounts, this represents an interest-free loan. One should understand that this is a special arrangement between a trusting and appreciative seller and faithful client. This represents a particular type of relationship based upon a long-standing history between the two individuals. Sometimes for a major purchase, a dealer will allow terms, but that is because they are realizing a great deal of profit from what represents for them an important transaction. Private parties in selling major works may wish to have you divide payments so that their income will span multiple tax years or some anticipated activity that they have a reasonable idea about the cost; like the future acquisition of the estate of an artist. One of my collector friends sold a single major work to finance an art museum he had promised his hometown.

You can discuss these payment considerations with your dealer in a candid fashion. One cardinal principle that applies to all human endeavor — the longer it takes to consummate a transaction, the greater the risk that one of the parties will become dissatisfied during this period. Art payment schedules for you should be considered an alternative, not a necessity and an accommodation that may well alter your behavior and acquisition patterns.

On a personal note on this subject, in completing my "Southern Paintings 1840-1940" collection, a major example of a rare but important artist became available through a well-known dealer who is a colleague and, I feel, a close friend. The asking price was "substantial" (that means more than you have available). Every effort was expended and every possibility considered to reduce or at least accommodate the debt burden for me. Exchanges and trades became too convoluted to offer much hope for mutual satisfaction. Thus, an outright purchase seemed to be the only reasonable alternative but sufficient funds for the purchase were not immediately apparent. A museum was "waiting in the wings" (isn't that always the case) for me to exhibit the piece. This would enhance the value of the work several fold. Learning of the museum's interest, the dealer became more flexible and we agreed upon a lower price, payment schedule, and discussed any contingencies or circumstances that might compromise the financial arrangement in the future. The agreement was successful because both parties appreciated the circumstances and the significance of the acquisition from my side of a troublesome equation.

We agreed to terms we believed would eventually work out well and it has. The painting became and remains one of the cornerstones of my collection. The point to emphasize here is that dealers will accommodate a client with a mutually satisfactory relationship if you are candid.

At first blush you would not think of going to a lending institution to borrow money to purchase a painting. Imagine your average conservative banker, already having been burned by loans on real estate and start-up companies for genetic manipulation, now listening to the wisdom of lending to a client who admits they will be putting a half million dollars in a perishable object about which neither he nor his advisor has any experience or knowledge. That same lender is also not likely to be impressed with your "collateral" of other paintings. However, circumstances are changing. Certain banks and other agencies are even offering a consultative investment service that includes advice to clients about the acquisition of art. You might presume that this service would include the arrangement by this same lending institution of loans to acquire art. Does this facilitation extend to those acquisitions that you select without consultation from the potential lending institution? Possibly, but a great deal will depend upon your collateral; as in size and nature. If these paintings represent a very small part of your overall assets and the success of the arrangement does not depend upon your disposal of some personal essential like your house, car, or favorite retriever, then the lender is more likely to view the transaction in terms of your ability to repay the loan rather than in terms of the wisdom of the acquisition. If the painting turns out to be a dog, they can always repossess your Maserati or your 80-foot Bertram.

Unfortunately, for some collectors, acquisitions become so compelling they lose perspective. You *can* live without it and the pain will gradually subside. Although you may think that the present opportunity for a particular acquisition is unique, this is rarely the circumstance. For even the mildly aggressive, there will be another chance for you to make the "most important" acquisition. You can adopt the posture that by "passing" you have saved your funds to make an even better choice at some future date. When you are out of balance with your acquisitions in relation to your resources, you can become so involved in paying for your art that you will not have time to enjoy yourself and that is a violation of the first principle. Collecting art should be pleasurable not painful, so do not overextend yourself physically or fiscally.

12
A Theme in Collection

Collectors often have significant difficulty in deciding about the initial or the first several acquisitions. While this is an important decision, understand it is not a permanent or irreversible one. Think of this as a learning process. By now you think experienced collectors have all the answers. If you will share your feelings of insecurity with them, your confessions of anxiety will be met with great compassion and quite possibly you will be regaled with their tales of inappropriate choices, even acquisitions of fakes, and multiple changes of direction. You will come to realize that most collectors have experienced these same bouts of insecurity and fear. These manifestations from your "acquiritis" will not give you ulcerative colitis or a noticeable chronic palsy. But can you benefit from the history and love of collecting and avoid some of the perils suffered by others? While there exists no better instruction in art collecting than personal experience, the tuition may be dear. I would recommend a collecting style that tends to minimize your risk and, more important, enhance your knowledge about what you are doing and provide you with confidence and pleasure as you progress. This style is collecting the various aesthetics (like, for example, impressionism), singly and specifically, creating a theme in your collection.

Books and articles about collecting art will predictably extol the virtues of acquiring personal knowledge about the kind of acquisitions you plan to make. This, as I have previously stated, can be done by visiting dealers, reading the academic offerings in the field, spending time in the appropriate museums, and exchanging ideas with other collectors. The acquisition of information, however, tends to be random, and, like all random data, is difficult to encode in one's memory and recall system. As an embellishment process, you can become competent and knowledgeable in a reasonable time frame by systematically studying the various aesthetics. In so doing, you will not only learn the traditional artistic canons of any particular art form but about individual practitioners of that particular technique (and the expected resource allocation to acquire an example). You will also come to know the physical or visual characteristics that must be in evidence to represent a quality example of that particular style.

As you move through the various aesthetics (impressionism, tonalism,

realism...), you may discover the ones you prefer and you can then concentrate on a particular artistic movement and even specific artists within that genre. This choice will be made based upon a variety of alternatives now known to you. It will become clear that, while these choices may have been made in consultation with others, you have largely relied upon your own judgement. It is now possible to go on with some confidence that you are responding to a synthesis of your own desires and tastes. Reaching this level of collecting is truly rewarding and every major collector will tell you so if asked. Without resorting to an encyclopedic litany of examples, several personal experiences in my collecting of American art might prove illustrative of this thesis.

Until the mid-19th century, the preponderance of American art was portraiture or modified portraiture. Early in our history and in the rural areas, documentation of one's existence, appearance, and station in life was deemed important enough to have likenesses fashioned by all manner of artists — from itinerant limners to the studio-based, academically-trained masters of New York, Boston, Philadelphia, and other urban centers. While sophisticated renderings of well-known figures have always been relatively expensive, the less well-documented portraits by unknown hands and the primitive works by self-taught artists have not. More recently, these stark, often decidedly two-dimensional images have been caught up in the general increased appreciation of Americana and folk art. Still, these "tokens of genealogy" remain of good value if you would like to acquire a survey collection, but having several dozen in one's domicile or a half dozen in one's office would be problematical from the visual perspective however, so this genre probably should be only a subset of your collection and not the theme.

By mid-century, Americans were coming to recognize the incredible grandeur of their native land, and this was celebrated on canvas by practitioners known as the Hudson River School. This thin application of pigment in a representational academic style of such notables as Church, Bierstadt, Moran, Cole, and Durand represents a body of widely acclaimed, eminently desirable work that many feel represents America's greatest artistic statement. While a representative example of these artists will be of lasting value, they are also quite expensive (in six to seven figures). There were many other practitioners of this aesthetic who created representative examples that can be acquired for a much smaller allocation of your resources. In studying this aesthetic and the related one, luminism ("American Light" as John Wilmerding describes this phenomenon), you will come to appreciate a significant aspect of American artistic tradition. If neither of these aesthetics is affordable for you, the academic self-discipline and information will still have been meaningful. Don't we all look at the Palm Beach real estate offerings or the exotic cars in the Robb Report knowing that this is a exercise in fantasy?

Certain art forms may be "good buys" or the possible subject of a survey or theme collection only if they appeal to you. Tonalism, which I will subsequently discuss, represents a technique in which the overall hue of the work is depicted through a thin veil of color from the lower key register. This is an aesthetic that has proved too evocative, moody, and at times, too serene for the general public to collect. This, along with the Barbizon mood of pastoral, wooded scenes of browns and greens, has been avidly collected, however, by some of the great patrons of American art such as Thomas B. Clark and Charles Lang Freer. One of the more celebrated of the tonalists was James Abbott McNeill Whistler. Some other artists closely associated with the American tonalist aesthetic were Dewing, Tryon, Dabo, Crane, Ranger and Murphy. Ranger also sought to establish an artist colony in Old Lyme, Connecticut at the turn of the century for "American Barbizon," a modified tonalism resulting in landscapes representing "paintings of quietude" and more generally accepted by the public. Any survey collection will be enhanced by several Barbizon and tonalist offerings. I once put together a theme collection of these works, wrote a small monograph, and had a traveling exhibit. This was very well received partly because the public had not been often exposed to these styles, recognized the scholarship, and appreciated the validity of the theme.

Bursting onto the American art scene in the last decade of the 19th century and the first decade of the 20th century was the most universally admired technique of all, impressionism. The opportunities for acquisition of impressionism are multitude. If you want to collect the leaders of American impressionism such as William Merritt Chase, John Henry Twachtman, Theodore Robinson, Edmund Tarbell, Julian Alden Weir, Willard Metcalf, Frank Weston Benson, and others, the best examples will cost you hundreds of thousands or even millions of dollars. However, you should still study their paintings and the technical characteristics of these masters to be able to appreciate the benchmark qualities by which the merit of any impressionist work should be judged.

Literally hundreds of American impressionists have been uncovered, discovered, rediscovered, and introduced to the collecting public in the past decade or two. These artists represent all manner of experience and training — from those studying directly with the masters to pupils of the great ateliers, artists who belonged to colonies like Old Lyme, CT; Bucks County, PA; Rockport, MA; Woodstock, NY; or Brown County, IN; some who stayed in France for long periods of time, and others who remained in obscurity by personal choice. Some of these artists produced works of such quality that they remain undervalued to this day, simply because they are lesser-known. If a collector has a discerning eye and an appreciation of the desirable qualities of the impressionist aesthetic, excellent and informed choices can be made. The

relative values can only be established by disciplined scholarship on your part, but the rewards can be great. They enliven a survey collection and offer a pleasing contrast to the portraiture, tonalism, Barbizon, and unembellished landscape paintings. My response to the values of the Chase, Tarbell or Benson offerings has been to collect extraordinarily good examples by their students.

Obviously, my discussion could take us through all the various movements in American art since the turn of the century, the Ashcan School, realism, modernism, regionalism, and the other "isms." These would also require some diligence on your part and more effort to understand them all. As the complexity of American life has increased, so has American art. This does not invalidate the methodology I have suggested in guiding one's collecting activity but simply makes it more interesting. Any focused scholarship will enhance the pleasure of the acquisition process and enable you to derive greater pleasure and satisfaction from your choices. A survey collection acquired in a disciplined manner will lead you comfortably through a number of passages. You can then enlarge upon a specific interest if you choose, but if not, you will still have a body of work that is interesting and visually pleasing.

13
Folk Art (The Visionaries)

Among the many currents of contemporary artistic fashion, folk art emerges as different and representing a rather extraordinary phenomenon. Contemporary folk art is not only well accepted by a broad base of collectors and art critics but has recently been the subject of genuine scholarly analysis by several well-recognized art historians. Many small museums have had folk or "outsider" (as a certain defined segment is known) art exhibitions, and future plans of almost every major museum include a celebration of these works. Contemporary folk art, I believe, is a powerful current phenomenon laced with elements of discovery and excitement for the collector.

Typically, folk artists have not had formal training, and their art does not conform to a traditional artistic style, nor does it evidence the characteristics of a known artistic technical convention. "Outsiders" appear to be almost self-driven, isolated from the mainstream, and with almost no awareness of historical artistic canons or the paintings of others.

The subject matter of contemporary folk art varies widely, from the simple and naive interpretation of historical events to the fanciful dreams utilizing symbols and traditions of apparent African and Afro-Caribbean culture as well as certain ancestor beliefs. For example, the bisexual masks of Lonnie Holley, a celebrated improvisationalist from Birmingham, Alabama, have many overtones of African face decorations. This is also the only American art tradition in which there is a predominance of Blacks, especially rural Blacks.

Many of these artists began by decorating their own environment without seeking validation or external praise and they continue to represent themes and objects from their everyday life. A compelling interest of these artists is the traditional American fascination with vodun (voodoo) practices, witch doctors, faith healers, mojo men, "haints", and the like. In the isolation of their origins and remote villages where they lived, these folk artists are a part of a semi-mystical and exotic culture. Sam Doyle, in his crude and powerful images of enamel paint on tin, depicted Dr. Buz, the medicine man of Frogmore, South Carolina, which is on St. Helena Island and populated by the Gullah blacks who were originally from the Caribbean. To Sam Doyle, Dr. Buz was not as mysterious as another of his themes, the apocryphal story of the appearance of Lincoln on St. Helena Island announcing the Emancipation

Proclamation several years prior to its recorded date in history.

To our contemporary folk artists, fantasies may be realities and there is little artistic constraint. At a time of world conflict and global uncertainty, the establishment will often harness their ambitions and seek a more traditional focus and set of values that are simple, direct, and with historical precedence. Many of these folk artists are fervently patriotic and incorporate in their art the celebration of American freedom and our way of life. For example, the Reverend Reuben Miller, in a very compulsive fashion, repeats the image of the American flag and has even dressed his personal icon, Blow Oskar, to have sartorial reference to Uncle Sam. Miller is very concerned about the global problem of terrorism and world strife. He believes that his whirligigs decorating his yard may offer some form of protection from the impending attack of infidels of every description.

Reuben Miller, like Howard Finster, and the late Reverend Benjamin Franklin Perkins and many other folk artists, is a former fundamentalist minister, dealing with quite tangible evil in a very visual, straightforward response. As our larger social problems become so overwhelmingly complex, the desire to simplify and reduce to an understandable focus becomes more and more compelling, as do the visual representations of these artists. The visceral appeal of their fanciful but simple solutions is indeed a part of this phenomenon, as are depictions of well-known biblical stories that profess hope and resolution or celebrate a fundamental event that is joyous and inspiring.

When one is beset with the intricacies of world crude oil prices, the incomprehensible national debt, the overwhelming defense budget, atrocities based upon ethnic rivalries, the interpretation of the Constitution, desecration of our national symbols, morals and ethics in public life, or even the value of artistic freedom and what represents pornography, it is quite understandable that these uncomplicated images of both simple intent and clear message have such universal appeal.

Somewhat less predictable in their appeal are the images created by these visionary or outsider artists that do not translate as easily into today's social context. Often, these objects and images were created by an individual for whom the endeavor had almost no external reason. The artist is driven, often in an almost compulsive fashion, to create images to satisfy an internal desire to simply make them. They were not fashioned to reflect any profound message or in response to any perceived external mandate. When asked about this phenomenon, most of the folk artists' responses will be neither profound nor particularly articulate. Willie Massey created his "tricks" since the early decades of this century, he explained, "'cause I can't do nothing else." The former slave Bill Traylor was 84 years old when discovered living outside his natural environment, the plantation, and drawing on the street in Montgomery,

Alabama "'cause I does it." While Massey's bird houses are in the low thousands or less, a major Bill Traylor will be in the $25,000-80,000 range.

Many of the folk artists claim a direct inspiration from God, from the simple "it's God's gift" pronouncement from the late Bessie Harvey to Sister Gertrude Morgan's marriage to "Christ the Lamb" in 1957. This revelation for Sister Gertrude came after a successful career as a street preacher, promoter of a child care center, missionary, and builder of a chapel in New Orlean's St. Bernard Parish. Her "marriage" further enhanced her resolve to purify the environment in which she lived. To answer this mandate, until her death, Sister Morgan painted her surroundings white and adorned her person appropriately with the theme. She punctuated her environment with her elaborately inscribed objects bearing messages of faith, religious principles and guides for Christian conduct. She was sometimes richly apocalyptic. Her exuberant palette has an element of both wild vibrancy and compositional intricacy.

Parallels can easily be drawn from the lives and creations of two of the most accomplished and best known folk art carvers, Elijah Pierce and Ulysses S. Davis. Both were born in small southern towns (Baldwin, MS and Fitzgerald, GA respectively). Each realized early in life that farm labor was not to be their chosen calling and began cutting hair at an early age (Davis by 10 and Pierce by 16). As one might imagine from the usual barbershop lore, learned and not so learned discussions of religion, politics, sports, and other "manly" subjects proved inspirational themes for both Davis and Pierce.

The "Ulysses Barber Shop" in Savannah was decorated outside and in with floral carvings; trim and window frames are incised with rose and tulip designs. Elijah Pierce and his wife converted his barber shop to create the Elijah Pierce Art Gallery. Both Davis and Pierce carved relief works which were often decorated with glitter, and each has shown an incredulity that their creations should be so highly acclaimed: "I didn't even know I was an artist until someone told me."

One of the reasons the late U.S. Davis never sold several of his masterpieces was that he had difficulty believing the vast sums he was offered represented their real value and "after I sold them I would be poor again." This is truly a refreshing viewpoint at a time when many of our contemporary artists and galleries, as well as museums and collectors, have been so greatly influenced by financial and commercial considerations. I will simply acknowledge that monetary considerations influence the contemporary artist and are a part of the judgement as to "importance" and even "value."

You can collect folk art in the high-rent district of major cities by visiting the galleries. This is efficient and relatively atraumatic. If you extrapolate from the circumstances related to Old Masters, Faberge eggs, Tiffany lamps, or post-impressionist paintings, you may believe you have no choice, because

this is where more than 95% of those works can be obtained. However, this is simply not true with contemporary folk art. These artists have the objects of their creativity occupying space in their own environment. After all, many of them created these works to make their habitat more attractive and had no idea nor cared that there was a market for their creations out there. Seeking out some of these folk artists is the ultimate acquisition adventure. Be prepared to go to places that are figments of some cartographer's imagination, wander into ghettos where gravity provides the "running" water, hollows that are still expecting the revenuers, and areas where snakes are worshiped and belief in "haints" is so strong it is tangible.

St. Bernard's Parish may sound a little strange, but it is much easier to find than Nada, KY; Wartrace, TN; Fayette, AL; or Girard, GA. If you ask for directions to "Bowfort" (Beaufort), SC, the natives may not help you find "Bewfert" because you obviously don't belong. It really doesn't matter because Sam Doyle passed away, and he lived in Frogmore on St. Helena Island, which is *near* Beaufort. As a collector, think about the prospect of finding your folk artist in Pinnacle no less. That's not a real town — more like an area. However, once you got there, you experienced a spectacle that any collector would envy. You knew when you had "found the wizard" because the late James Harold Jennings decorated the whole environment.

Howard Finster's "Paradise Garden" has been filmed, documented, and regaled on national talk shows, but riding down the road near Lucama (that's near Williams), NC and seeing the 40-60 foot windmills, whirligigs and other monstrous metal creations of Vollis Simpson is an entirely different experience. On a smaller scale but equally intriguing were the four school buses amid expressions of the Reverend of Metaphycosis (or was it psychosis?), Parson of the Sun and Stars, James Harold Jennings. When the artist rode up on his bicycle bedecked with a toboggan, shoulder-length hair, a leather vest filled with brushes, and carpenters instruments arranged in fisherman's style, shorts, and hiking boots — all topped by a wooden crown — you had an idea that the verbal exchange was going to be interesting.

Then there is just the experience alone of acquiring the object of your desire from the person who created it. You are certainly not going to discuss auction records or prices for other folk artists, because the most insulting thing one can do to this independent breed is compare them with anyone; they probably never heard of the other artist, even if they have they simply could not care less. Nellie Mae Rowe's comment when asked about the virtues of the museums of New York City, which she had been given a whirlwind tour of, was — "I got paintings at home." Even more interesting and endearing in today's art world, the artist is often not interested in the price; the dilemma may be to decide if you should have one of their examples or if they should part with their creation.

The dialogue with the artists is usually thoughtful and even paced when you ask them about their lives but can become exceedingly intense when you ask them to interpret their images. I was treated to at least a 20-minute monologue from the late Bessie Harvey about the superiority of women ("men folks is so pitiful") and from Lonnie Holley on the evils of drugs. The right reverends Reuben Miller, Robert Roberg, or Howard Finster will weave a convoluted tale involving religion and politics and laced with just a pinch of supernatural. You will be very glad that you asked.

Unquestionably, every avid collector will extol the virtues of the activity surrounding the process by which they acquire and appreciate the objects of their desire. I have progressed in my various careers through American impressionism, decoys, oriental rugs, long-case clocks, vintage motor cars, and antique furniture. I haven't attempted old tires, neon signs, wooden tennis racquets, highway markers, or styrofoam deer but have an open mind. However, for the sum of my experience I can recommend the collection of contemporary folk art on location in the manner I have attempted to describe. You might even relate your acquisition of one of these artist's creations to a true religious experience, compare the search to a modern day quest for the Holy Grail, or your encounter to a visit with Rasputin, Merlin or maybe even a latter-day Will Rogers.

The real joy of collecting contemporary folk art is to meet and exchange ideas with the very creative persons these artists will invariably prove to be. Collectors, art historians, museum curators, and dealers can all share in this dynamic process. In almost every aspect this is a departure from traditional artistic thinking, acquisition opportunities and dealer/collector involvement. I have been able to publish a number of manuscripts and catalogues as well as exhibit my collection a number of times in various museums and institutions. For me the satisfaction of introducing one of these unique individuals to the public is very rewarding — I recommend it.

14
Self-Taught Artists

Some of the earliest examples of art are the cave drawings of Europe and images on papyrus of the Middle East and Egypt. These are pure expressions and communications created by self-taught and unknown artists. Through their portraiture in the early centuries of our country, often nameless and unidentified limners traveling about the American countryside created a national documentation of persons and lineages. These artists often had no academic training. We have always admired individuals known and unknown who have made significant artistic contributions, irrespective of the type of endeavor or the nature of the accomplishment itself. The group of artists that I would like to focus upon in this chapter are the 19th and early 20th century painters who created primitive, often naive images of well-known subject matter that have a uniqueness and charm that make them collectable.

I have discussed the current fashion of the contemporary folk artist "outsider" or "isolate" who is indeed self-taught but in addition, creates images that do not appear to follow traditional artistic conventions nor are they inspired by historical painting techniques. The images often appear as the visual representations of psychological, often subconscious stimuli. In the self-taught artists (often termed "naive" or "primitive"), we are dealing with a different, albeit related phenomenon and I believe that the considerations of merit lie somewhere between those traditional criteria and the isolates.

Many self-taught artists had the inspiration to create images of their vocations and avocations. As an example, a few of the most famous hunting guides of the 19th and early 20th centuries became accomplished waterfowl decoy carvers, but some were self-taught painters as well. Often, these paintings would be correct in the depiction of the waterfowl and even the gaming technique employed but charmingly "out of kilter" regarding landscape perspective. A curlew might appear in the same plane of the image as a greater Canadian goose and be portrayed as the larger object. However, these gaming pieces often demonstrate a sophistication in the artist's imagery of atmospheric conditions because the guide observed these phenomena so many times that their level of appreciation due to experience would be far superior to most trained artists. One must understand that these waterfowling paintings by self-taught artists do not rival or compare with a Frank Weston Benson (at

$250,000) but might be acquired on an entirely different premise and for a great deal less.

Self-taught artists often wish to document their locale, providing a travelogue image. Collectors also familiar with a certain scene often delight in the charm of these works, which, in fact, do not adhere to structural or geographic correctness but provide an interesting if somewhat incorrect perspective. Scholars speak of a "stiffness" of quality generally to be avoided in traditional art forms but which is often revered in the works of self-taught artists.

Religious themes have provided great inspiration and subject matter for many self-taught artists. Familiar biblical passages and stories treated in the highly personal manner of a naive artist can be extremely appealing. These renderings will usually represent a literal translation of the words from the religious source, as most self-taught artists follow fundamental interpretations (Jonah was actually in the gastroesophageal junction of the whale, the Red Sea indeed opened to provide a dry corridor through which God's people could walk, and the Ark truly contained all of the species of animals in matched pairs).

Periodically through our history, war, in all of its elements, has provided the stimulus for certain participants to capture the images that they experienced or were described to them. The War in the Desert recently superseded the personal interests of most Americans as a current example. The war with the most vivid imagery in the history of our nation, however, was the War Between the States. More than 1000 artists were hired to document this conflict pitting friend against friend, brother against brother, and American against American. Soldiers, in their infrequent free moments, despite exhaustion, often hunger and sometimes pain, created documentary images of this war that today provide unique insights into the mystery and misery of civil strife.

Certainly, the Civil War had battles and encounters that are familiar to every American, like Pickett's charge, the Monitor and Merrimac, Sherman's march to the sea, or the surrender at Appomattox. These have provided inspiration to many self-taught artists who wished to create in a visual image their own version of these events — some providing a charming departure from historical fact, while others produced an overcrowded documentation of preceding and antecedent occurrences.

A certain group of self-taught artists was inspired by a need to accompany their literary work. These often multi-talented, creative individuals wanted to further share their thoughts and ideas through visual imagery. The Reverend W.A. Cooper was just such an example. Born in poverty (his father was a field hand who "raised possum dogs"), Cooper was sent to college at the age of 14 or 15 to study theology and by age 22 had, in addition, completed the bar examination. He became a highly respected minister who wrote a series of

articles to improve understanding between Blacks and Whites. In his book, Negro Life, Cooper's primary theme was that, if given the proper opportunity, a Black could succeed though industry and education in the Establishment. He chose successful Blacks, especially from the professions, arts and education as examples and taught himself to create portraits of those people that he knew personally. His works, though rare, are highly collectable.

The largest group of self-taught artists are those who remained in the household and created images of familiar objects for their own satisfaction and amusement. These images do not often contain any profound social statement or inspirational message for the viewer. There is no mystery in the subject matter. The charm and desirability of these paintings are in their imagery. If you want to acquire paintings for eventual profit, I think you should seek your acquisitions elsewhere; Grandma Moses and Ammi Phillips notwithstanding. However, if you aspire to have a very interesting and unique collection, then images by the self-taught artists will provide just such an opportunity.

My intent has been to introduce the concept of acquiring self-taught artists and not necessarily to legitimize this manner of collecting. The charm of these images is a matter of interpretation — an ability inherent in all humans. My comments have hopefully provided some ideas by which these artists might be evaluated. I have personally collected traditional portraiture but have also enjoyed paintings by self-taught artists of activities not usually portrayed in fine art. There are certainly collectors out there if you attempt to acquire a Grandma Moses or an Ammi Phillips, so realize that you are not alone in your quest. As a practical matter you are more likely to put together a representative collection that will depict self-taught art generically than 30 examples of Grandma (as in "grand") and Phillips. In the next several chapters I will discuss what I believe will be genres and painting techniques more familiar to you.

15
Tonalism

Of the painting esthetics, tonalism is among the most personal and probably one of the most misunderstood. If you are not familiar with this genre, take heart because many of your fellow collectors are not either. Although deriving from the Barbizon technique, tonalism is also considered to be related to impressionism and may be a refined derivation of both. As a characteristic painting style, tonalism was adopted by only a few artists. Tonalism is an intimate style of painting which expresses themes in a limited color scale. Form is perceived through an overall colored atmosphere which provides an even hue to the painting.

Technically, tonalist paintings are constructed using varnish as a medium, and colors are mixed not on the palette but on the canvas itself. The technique of glazing is essential to tonalism, just as for the Barbizon aesthetic. Through glazing, the artist can achieve the harmonious diffusion of light and have a dominant hue reflected through the entire painting. Glazing also allows softening of the edges of the compositional elements. Landscapes can be portrayed as fragments of nature veiled in a monochromatic mist. In tonalist compositions, light becomes the expressive protagonist; whereas in impressionism, light is itself the force of the composition. Landscapes are often devoid of figures and tonalist compositions fail to have the sparkle and flair of impressionism. Tonalism is aesthetic rather than analytic art, emphasizing a cerebral, reflective attitude of painting. The simplification of both composition and tone can make these paintings somewhat lifeless and, in the opinion of many collectors, at times depressing.

The art historian E.P. Richardson described tonalism as "paintings of quietism." These paintings characterize quiet days and moonlit nights. Leaders of tonalism such as James Abbott McNeill Whistler did not portray the details of nature with exacting verisimilitude (a fancy word for truth) but projected nature's mood. Whistler sought to remove painting from its conventional literal context and supplant scientific fact with "poetic truth." Captured in the tonalities and modulations of the painting are nature's quiet and still moments. The artist's private and personal experience of nature is conveyed to the viewer by the magic pall of subdued light. Figures in these tonalist landscapes are depersonalized and dissolved in the ill-defined penumbra of

prevailing color. Objects are perceived in uniform light to express the evocative moodiness of the composition.

Tonalists characteristically chose the seasons of winter or late fall for their subject matter, lending their paintings to the lower register of the color scale. These artists could interpret themes in an envelope of mist and avoid intense contrasts of light and shade; they conveyed aesthetic pleasure in subdued tones and interpreted natural themes in softly contoured pervasive melancholy. Whistler and other tonalists such as Leon Dabo and his brother Scott, referred to their highly reductive compositions as symphonies. This was an effort to suggest a combining of visual and musical sensibilities. These artists often spoke of their efforts in terms of harmony.

Nocturnes are essentially tonalist compositions. The diffusion of light from the moon and stars is, by nature, almost monochromatic. Nocturnes often convey a pensive and cerebral mood; the edges of structures are indistinct, suggesting rather than representing their presence. Nocturne painters in America never formed a distinct group but neither did the tonalists. Many of the artists emphasizing these two techniques were the same. In 1896 the tonalists had an exhibit at the Lotus Club in New York. This may have been as close as they ever came to representing an organized movement in American art. The artistic leadership in America was provided by Henry Ward Ranger who founded what he called the "American Barbizon" at Old Lyme in 1899.

Few patrons were available to the tonalists, but among those who did champion and support this movement were some very important figures in American art. The best known was Charles Lang Freer, who collected the tonalist works of Whistler, Thomas Dewing, and Dwight Tryon. His collection now represents the major holdings of the Freer Gallery in Washington. Every collector of American art should visit this collection.

The principle patron for the Barbizon School was William T. Evans. Evans had an important advantage as a collector in having Henry Ward Ranger as his advisor. Evans was chairman of the Lotus Club Art Committee for over a decade. He, along with Freer, believed that art should be placed in public institutions to educate the general public and assisted in founding what was to become the National Museum of American Art.

The exhibitions of George A. Hearn's American collection also provided a public forum for the tonalist aesthetic. George A. Hearn, like his colleagues William T. Evans and Charles Lang Freer, was concerned with educating the American public about the importance of our native artistic expression. He was instrumental in the establishment of the Metropolitan Museum of Art, and his donations to that institution included a number of tonalists such as Ralph A. Blakelock, A.P. Ryder, Bruce Crane, Elliott Daingerfield, J. Francis Murphy, Alexander Wyant, and Dwight Tryon.

Thomas B. Clarke was also a champion of the concept that Americans should appreciate and collect American art. He, along with these other influential collectors, considered tonalism to be a truly American art form. They felt that the derivative nature of impressionism and the Barbizon aesthetic could be directly traced to the leaders of the French school with significant influence from Munich in the Barbizon style.

Clarke had an important affiliation with numerous art clubs and a personal friendship with artists such as George Inness and Homer Dodge Martin. He loaned many tonalist works for exhibitions at the National Academy of Design, the Metropolitan Museum, the St. Louis Exposition, the World Columbian Exposition (1893), and the Pennsylvania Academy of Fine Arts. In 1899 Clarke added an economic sanction to the collecting of American art and tonalism when he sold his collection at auction. This, in some ways, translated the value of works by American artists into the marketplace.

Despite these influential patrons and their championing of American art through tonalism, the movement (if it ever achieved that status) has been appreciated by only a few collectors and the contribution of tonalism to later movements in American art has never been properly recognized. The exhibition reviews in the last decade of the 19th century by art critics of the tonalists, exhibiting as the Society of Landscape Painters, described Barbizon and tonalist paintings as "monotonous, too devoid of life, and possibly too aesthetic."

The concepts of tonalism are often as difficult for us to understand as are the painting techniques employed to create these images. With the excitement of our bridges and skyscrapers and portrayal of the activity of our ports and recreation areas from other styles, the intellectual posture supporting tonalism could simply not be sustained. Competing with the vivaciousness and crude vigor of the Ashcan School and their emphasis on familiar urban subject matter and the ferment and exciting drama of modernism, tonalism as a collective movement soon became history. However, the legacy of this aesthetic should not be underestimated. Tonalism remains to this day as an influence in artistic composition and continues as an appealing representation of American artistic expression. The synthesis of technical skill and emotional sensitivity necessary to produce a representative example of this aesthetic is a compelling feature of tonalism and it will always have its devotees. Every painting you acquire is "personal" but your tonalist paintings are very personal. I am drawn to tonalism, especially of Southern subjects, as are my fellow collectors Roger Houston Ogden and Billy Morris. The number of collectors of this painting style is growing, but very slowly.

The writings of Buck Pennington, Wanda Corn, and Robert Preato have greatly influenced the appreciation of the public for this aesthetic. The tonalist

84

exhibitions in 1972 at the DeYoung Museum in San Francisco and in 1982 by Grand Central Galleries were both academic and commercial successes. The publications accompanying these efforts have become useful and classic references on this subject. About a decade ago I had an exhibit of this technique as the predominant theme. I must admit that, while this was an intellectual success (as was the monograph), it was more soothing than exciting.

For the initiate this aesthetic may not be appealing at first and you can wait until your level of education and appreciation make you more comfortable in acquiring these paintings. Realism and impressionism are much easier to understand and will also broaden your perspective. I have found this true both as a collector, exhibitor and a would-be art historian. Thus, tonalism is a genre that you might wish to be conservative with in your early commitments. Try it on and if the shoe fits....

16
American Barbizon and Ashcan Schools

The particular aesthetic practiced by artists painting near Paris in the forest of Fountainbleu and in the Dutch lowlands created a body of works collectively known as the Barbizon tradition. Beginning well before mid-century, artists such as Corot, Millet, Daubigny, Rousseau, and Diaz depicted the rural landscape, the peasants at work, farm animals, and the virtues of agrarian life. This was done partially as a social statement in opposition to the growth of an increasingly industrialized and urban European society.

The Barbizon artists were indebted to the tradition of the English landscape painters such as John Constable and to the 17th century Dutch painters, vanRujsdael, Hobbema, and VanGoyen. They created pastoral images in a dark matrix of russet and golden browns, upon which they often superimposed flecks of yellow and orange. Utilizing tinted glazes and multiple varnishes that produced a lustrous sparkle to their works, the subject matter was perceived through a somewhat tonalist veil of earthen hues.

Barbizon artists were able to imbue the landscape with a personal view — an alternative certainly to the heroic and awe-inspiring vistas of the American Hudson River School. The toil of the farmers and laborers, although having an element of melancholy and despair, also contained a sense of nobility and dignity. This, coupled with the low key palette of Barbizon works, has traditionally made it difficult for many collectors to "understand" or be attracted to the Barbizon aesthetic. You may also find these paintings uninspiring and if so, collect another genre — like impressionism. However, I think this is, at the very least, an important movement in American art and you should expose yourself to it.

The first artist to return to America and emphasize the Barbizon aesthetic was the Bostonian William Morris Hunt who studied with Jean Francois Millet in 1853. George Inness Sr., in my opinion America's premiere intimate landscape painter, was also exposed to Barbizon painting in France and subsequently turned to a more subjective interpretation of natural phenomena. Inness influenced an entire generation of landscape artists to

follow this perspective, including his son. Any work by him that you can accommodate financially will bring its reward in ownership.

In the late 1880's and 1890's, Henry Ward Ranger made several trips to the Barbizon Forest and to Holland as well. He was not only a highly respected American landscape artist but a colorful personality possessing great qualities of leadership. In 1899, Ranger was convinced that he had a firm grasp of this painting technique and could form an American Barbizon in the lovely town of Old Lyme, CT. He described the gentle landscape, the seasonal rhythms of nature, the elegantly gnarled old oaks, the estuaries and tributaries, and the tree-lined streets of the village as the "land of Millet."

Returning to Old Lyme and the conviviality of the Griswold Mansion in 1900, Ranger spent the next three years persuading from twenty-five to thirty of his fellow artists to summer there and create paintings using the Barbizon artistic persuasion. The countryside near Old Lyme is spectacular in every season and the varied nature of the adjacent geography permitted the artists great latitude in their choice of subject matter.

Guided by an understanding of the Old Master technique of glazing (the application of successive layers of pigment-tinted varnish), these artists in the early days at Old Lyme created images in which light could penetrate the surface and be reflected back to the observer. Their emphasis was upon a poetic interpretation of common labor and a very subjective depiction of nature.

While the Barbizon aesthetic was an important influence in American landscape tradition for many decades, its life as a movement in American art was, indeed short. In Old Lyme, for example, with the arrival of Childe Hassam and J. Alden Weir in 1903, the Barbizon mood which they derisively referred to as "brown gravy" painting came to be rapidly replaced by the light, bright, flickering images of impressionism. In 1904, a disappointed Henry Ward Ranger moved eastward a few miles to Noank and with some of his colleagues formed the Old Mystic Colony.

Paintings representing the Barbizon aesthetic are traditionalist, somewhat monochromatic, and subtly convey a mood of tranquility, pensiveness and are sometimes melancholy. They do not create the visual excitement of impressionism nor the dramatic social statement of the Ashcan School or abstract expressionism. However, Barbizon paintings are not as mystifying as the various nonrepresentational movements known collectively as the "isms" that followed. In some measure, the Barbizon tradition has been relegated to museum exhibitions and like tonalism, not widely collected. I believe, however, they can add immeasurably to a survey collection or be enjoyed individually *and* they are underpriced if you judge them on the basis of quality.

In present American life consisting of overriding elements of unpredict-
ability and inconsistency, the images of the Barbizon mood may be appeal-
ing in their simple portrayal of timeless values (is the politically correct term
"family values?"). I think they are both sufficiently reductive and visually
understandable to bring about a modest future rise in collecting interest. The
tranquility and subtlety of Barbizon paintings should increase their contem-
porary appeal as our world continues to increase in complexity. They will
never surpass impressionism in public interest but will certainly mix well
with paintings of this aesthetic in exhibition or your home for that matter.
I find them particularly attractive in a more intimate format of display in
your "private space."

As collectors we are constantly redefining our understanding of certain
aesthetics. This is an ever-changing process because American art can be
characterized by a number of short-lived but significant movements. Among
the more short-lived but influential, was that realist aesthetic begun by
several newspaper artists in Philadelphia led by Robert Henri. These
painters, after moving to New York, became known as the "Immortal Eight"
and later were placed in the general context of artistic history as the "Ashcan
School."

The Ashcan School could best be characterized as the style of Henri, John
Sloan, George Luks, and those later artists like George Wesley Bellows,
Isabel Cohen, Eugene Thomason, Eugene Higgins, Guy Pene DuBois, Leon
Kroll, Walt Kuhn, August Lundberg, Jerome Meyers, and Walter Pach, who
all followed a similar style and a sensitivity for a common subject matter.
These realists saw themselves as expressing American life and as capturing
the social forces of their native land in these visual images. Their departure
from the rigid, conservative tendencies of the National Academy of Design
and the painterly, bright images of "The Ten" and the Society of Landscape
Artists begged for a reaction, which was indeed forthcoming from both their
fellow artists and the general public as well.

The thesis of Henri, Sloan, Luks, and others was that American art should
reflect the current social phenomena of this vigorous nation depicted in a
bold, realist painting style. They sought not to capture the beauty of sunlit
gardens, the vistas of the American West, or interior genre scenes of women
in elegant attire engaged in genteel, leisurely activities. Instead, these
painters chose to depict the images of urban construction and city streets
teeming with vendors and tenements. They celebrated the struggle of those
immigrants who had just arrived in the land of opportunity.

The leaders of this group had, indeed, been newspaper artists covering the
instantaneous happenings in the city of Philadelphia, while at least one other

(George Luks) had followed the fortunes of Americans in the Spanish-American War. They learned to create paintings rapidly by the technique of blocking in the "sense" of the images with large summary strokes and later completing the work by adding the corpus and details of the picture. For the subject matter of interest, they chose darker pigments at the lower end of the color register rather than the light, "blonde" palette of impressionism or the warm luminosity of traditional American landscape painting. The detail of the Barbizon artists and the subtle moodiness of tonalism were purposely lacking in these much more bold, provocative works. This was true realism about very real contemporary events.

Henri was the acknowledged spokesman of the group. His insightful lectures and essays often served as the collective statement of The Eight. Henri also regarded himself as a leader in artistic progress that was to celebrate contemporary American life and its major social statement. His portraits and figure caricatures were meant to capture the phenomena and effects of urbanization, capitalism, and the influx of European immigrants to America. The member of The Eight closest to Robert Henri in style and purpose was John Sloan. In a similar, realistic manner often employing grays and other darker pigment tones, he would portray city life in New York and the commerce and movement of the steadily growing numbers of people.

George Luks was the only member of The Eight whose colorful personality and flamboyant life-style rivaled that of Henri. Luks was ribald, sometimes charismatic and thoroughly unpredictable. He was a frequenter of bars, the burlesque, and a friend of the street people as well as the champion of the oppressed. His paintings were often summaries of draftsmanship in which the essentials were hastily rendered and enough detail was added so that the viewer gained the "essence of the composition leaving room for the imagination." Luks was greatly admired as a teacher, especially due to his lively demonstrations. He also attracted enemies and died rather mysteriously by falling down a flight of stairs in 1933.

Another of The Eight was enamored with American life surrounding the theater. Everett Shinn was an actor of sorts and painted stage sets, theater interiors, and the actors themselves. He was later to illustrate 28 books, 94 stories for Harper's, and was the art director for Metro-Goldwin-Mayer. Although his subject matter was different from that of Henri, Luks, and Sloan, his technical style has definite similarities. Collectors are often attracted to the exciting treatment by Shinn of the theater and the associated life-style.

The "Immortal Eight" was never a true marriage of artists but only a liaison of convenience as other members of the group were not similar in the

painting style nor in their choice of subject matter. William Glackens has often be called (and with some justification) the "American Renoir." His personal New York was composed of elegant ladies and their prosperous men, boating parties and picnics in the lovely surround of Long Island Sound.

Certain works of this group were visual representations of public fantasy and were very popular with the public. Maurice Pendergast was a unique mosaicist who captured the urbanites at leisure. He has been often described as a "neo-impressionist" and is well known also for the 200 monotypes he did to develop subjects by variations in color rather than the visual subject. Pendergast is very expensive because his painting style is unique and collectors seem willing to pay for this quality.

Another member of The Eight, Ernest Lawson, was by most standards an impressionist who studied with John Henry Twachtman at Cos Cob, Julian Alden Weir, and with Laurens and Constant at the Acadamie Julian in Paris. Lawson portrayed New York in a bold, bright, heavy impasto technique creating images that had the scintillating qualities of "crushed jewels." Arthur B. Davies was a versatile artist whose media ranged from watercolor to oil, wood, ivory, marble and wax, lithographs to etchings, enamel to glass, or Gobelin tapestry to finely woven rugs. Davies was a mystic and a romantic whose favorite image was a landscape occupied by nymphs and allegorical figures. Thus his association as a member of this group was more intellectual than aesthetic. He tends to be less expensive than the others of this group but you are, in my opinion, acquiring an Arthur B. Davies rather than a painting representing the characteristic qualities of the Ashcan School.

The exhibition of The Eight in New York City (1908) shocked the public — not only because of the painting style but in the artists' choice of subject matter. In a review of the exhibition, one famous critic, pronouncing the work as "dreadful," stated that the theme appeared to be a demonstration of "clotheslines and ashcans." This phrase was so often repeated that "ashcan" came to be associated with the painting style espoused by several of The Eight, their students, and their followers.

"Progress" to the art establishment is often represented by merely an accumulation of the lessons from the previous artistic experience. There is also a tendency to equate artistic insurgence with political radicalism. Change can be viewed in a negative context rather than as progress. The Eight saw their exhibition in 1908 as the beginning of their ascendancy to the most influential positions in the structure and conscience of American arts. Little did they know that as a clearly identifiable movement, this show in 1908 may well have been their zenith, for by the famous Armory Show

of 1913, modernism had emerged as the favored direction of American art. The modernists saw themselves as expressing fundamental artistic principles, and their statements were such departures from artistic norms that they captured the imagination of the public. The Ashcan School was in decline almost before it became well known.

By the time of the great Armory Show, only Davies was involved in the governance hierarchy of the exhibition. However, the influence of the Ashcan School remained significant throughout the 1920's and 1930's. Their legacy can be seen in the emergence of the regionalists such as Thomas Hart Benton and Grant Wood and to some extent among the most accomplished of the WPA artists whose realistic works reflect this artistic influence. Many of the more popular instructors of the Art Students League taught the realist style espoused by the Ashcan School for several decades after the Armory Show. Thus, their aesthetic life was greatly extended.

The importance of The Eight and the Ashcan School in American art should not be underestimated, as they were largely responsible for establishing the legitimacy of everyday American life as an appropriate subject for visual art. Whether or not you are sufficiently attracted to the bold images with their direct social statements, to collect them is quite another determination. Several are monumentally expensive while others the primary determinant of cost is the subject matter. For example, a Henri portrait of a child or a Spanish female figure will be over $100,000 and several hundred for the painterly ones. However, a standard portrait of a man can be acquired for $50,000 or less. Let me caution you, only buy the less expensive if you think the painting is technically good and demonstrates the same painterly qualities as the image of the child or the female, otherwise you will eventually be dissatisfied.

You might think the followers might be less expensive, but George Wesley Bellows and Thomas Hart Benton certainly are not. Eugene Thomason is an artist I collect because he paints like George Luks at a fraction of the cost. Thomason and Luks had an "advanced" art school (1921-1932) for students that had received training at the League. Thomason's style was so much like Luks that with some of their paintings it is difficult to determine the artist. Lib Williams Thomason (a graduate of Julliard) told me after I discovered her living in the North Carolina mountain village of Nebo, that "Tommy" finished a number of Luks famous commissioned works when George "was on a tear."

Most of Thomason's works were retained by his widow and children. The archival material Lib had retained was extraordinary and contained extensive correspondence with George Luks and other members of the Ashcan movement. After using this for our small text, <u>Eugene Healon Thomason;</u>

The Ashcan Artist of Appalachia, Thomason's family and I gave all the data to the Archives of American Art. As a collector I felt we had made a real contribution. The retrospective at Knoke Galleries in Atlanta placed Thomason's work in several important museums and I donated most of my Thomason collection to the Mint Museum, Cheekwood, the Asheville and Hickory Museums, the Greenville Museum of Art, and the McDowell Art Center near his home.

These Ashcan paintings are strong so make certain you can live with them — especially if you are planning to acquire "Bellows Fight at Sharkeys" for about a million or so dollars! Barbizon paintings and the Ashcan School are not as widely appreciated as the next school we will discuss, impressionism, but you have the right of personal choice and they can certainly embellish any private collection.

17
American Impressionism

Impressionism is considered to be the most universally appreciated paint-
ing style and with good reason. The elements of pleasant subject matter, light
and bright pigments applied in such a manner as to connote vibrancy and
movement, and the summary treatment of form to provoke your imagination
have given impressionism widespread public acclaim for over a century and
the enthusiasm for this genre will continue. Many contemporary artists
working in this aesthetic have achieved a large and loyal following.

Conventional wisdom has been that American impressionism is a deriva-
tive art form based upon the stylistic legacy of the Europeans, chiefly the
French. A number of American artists traveled to Paris to receive training in
the 1880's and 1890's where they studied in the salons of the Academie Julian
or the Ecole des Beaux Arts. Upon their return to the United States, these
artists wanted to duplicate the experience they had in Europe and did so by
founding and changing the format of various American art schools, such as the
Boston Museum of Fine Arts School and the Arts Students' League in New
York. They also formed art colonies, such as Shinnecock on Long Island, and
Old Lyme in Connecticut in direct response to this legacy. Other colonies
followed. Although the impressionists had their first collective exhibition in
1874, it was several decades later that this technique of painting became the
dominant one in America.

As American impressionism is based on the styles of the Europeans, the
value of works by even the more important artists of American impressionism
should not approach that of Monet and his colleagues. While Monet, Pissaro,
Degas, and their equals have been beyond the resources of most collectors for
many decades, Childe Hassam, William Merritt Chase, John Henry Twachtman,
Frank Benson, Willard Metcalf, and Edmund Tarbell have only been rela-
tively "unaffordable" since the mid-1970's.

Mary Cassatt, although largely an expatriate who painted in Paris with
Degas and his circle, is considered by many to be an American impressionist.
A pastel (her preferred medium) by this artist sold recently for 4.5 million.
While this is far less than the 53 million achieved by Van Gogh's "Irises", it
is well beyond the means of most of us who would or want to be collectors of
American impressionism. Even the paintings of artists who would have been

characterized as "second line" impressionists, such as Frederick Frieseke, Lawton Parker, Richard E. Miller, and Louis Ritman, have fetched hundreds of thousands of dollars, making their acquisition by the majority of us problematical. However, this does not mean we should despair. Despite the incredible increases in value, the American impressionists can still be acquired in general for less than their European counterparts. At a different level from those with seemingly endless resources, and one in which there are many theoretical participants, is the American impressionism I will discuss.

Many collector/investors believe that the publication of Bill Gerdts' text on regional schools of American art will continue to increase the demand for paintings from such impressionist colonies as Brown County, Old Lyme, Rockport MA, Carmel CA, the Broadmoor in Colorado, Burnsville NC, and Provincetown MA. I will discuss several of these colonies that I have collected due to my interest and emphasis of regionalism.

The interesting and well-illustrated texts by Boyle, Hoopes, Pierce, Pisano, and Gerdts have increased our awareness and appreciation of American impressionism. Concomitant with this knowledge has been a general increase in fervor of acquisition as well as a marked escalation in the value and price of these impressionist works. There is simply no question that texts of this type can enhance, if not create, a demand.

Some art advisors would state that collecting these expensive paintings is an appropriate investment alternative to traditional stocks and bonds, equity positions in businesses, real estate, or futures — each having its own appeal for the participants. Some investment advisors believe that American impressionist works can be treated as a commodity to be bought and sold in a relatively emotionally unattached manner. As any type of commercial venture, success can be achieved by purchasing goods for less than their resale value, marketing the acquisition and disposing of it for profit. With an American impressionist painting, you will achieve the additional interim reward of being able to have an object of aesthetic appeal to embellish your home or office, or to exhibit in a public place for the appreciation of others. In a strict business sense, these additional opportunities should not be decision factors, but in reality they most certainly are for the collector. Even with these incentives I would be fiscally conservative because this is still an illiquid commodity.

A number of recent publications in financial journals, art magazines, and commercial communications have charted the growth of the Dow Jones average, real estate, mutual funds, and money investments versus paintings of many genres as well as other collectibles. Except for some rather extraordinary growth in specific collectibles dealing with a limited supply of individual objects and collector demand, paintings of the old masters and examples of

American impressionism appeared to do best in these general comparisons. The trend for over a decade has been sustained growth in value, with momentary periods of geometric growth. If you as an investor in art are fortunate enough to acquire paintings by a particular artist who is shortly to be "discovered" by a famous gallery or whose paintings are to be featured in a traveling public exhibition or whose works are to be the subject of a retrospective, the financial rewards can be extraordinary.

To gain full measure of this phenomenon, the painting acquired by you must evidence the characteristics that warrant the renewed attention or interest from exposure paid to this artist. For example, the wonderful exhibition "American Light" organized by John Wilmerding and his colleagues at the National Gallery increased the awareness of the American public of the virtues of luminism to the point that representative examples of that aesthetic began to command prices that were several multiples of the pre-exhibition value. I would like to share my personal experiences in several of these "discovery" phenomenon.

In the mid-1970's, the ambitious three-site exhibition of Connecticut impressionism at the University of Connecticut at Storrs, the Hurlburt Gallery in Greenwich, and the Griswold Mansion at Old Lyme not only embellished the image of notables such as Childe Hassam, John Henry Twachtman, and J. Alden Weir, but greatly increased collector (and investor) interest in the lesser-known figures of this group such as Edmund Greacen, Walter Clark, Elmer Livingston McCrae, William Chadwick, Will Howe Foote, Henry Rankin Poor, Charles H. Davis, William S. Robinson, and Clark Vorhees. Additionally, the value of the works by Bruce Crane, another of the Old Lyme artists, were further increased by Charles Teaze Clark's article on the Barbizon artists in Antiques magazine. The paintings I owned by many of these lesser known artists increased greatly in value without any effort by me.

There is a certain amount of "fashion" on any type of investment. Junk bonds are a poignant example of this phenomenon. With the numerous exhibitions featuring impressionism as an aesthetic, the relationship to Claude Monet and the environment at Giverny have been greatly emphasized. Those American artists who lived in the village and painted in close proximity to the "father of impressionism" are now very much in vogue, and the value of their paintings has escalated markedly as a response to this mind set. The works of Frederick Frieseke, Lawton Parker, Theodore Earl Butler, and Richard E. Miller are well into the six figure range, with major examples over $500,000. A little-known member of that group, Louis Ritman, achieved $418,000 at auction when collectors suddenly realized the magnitude of prices commanded for the others and that the best works of Ritman had the characteristics which made them so desirable, such as light palette, dappled sunlight with

ladies in flower filled gardens. I had an interesting experience with a cache of Ritman's retained by a family member. When he returned to the United States, Ritman embraced modernism and 90% of these holdings were that. My son found a wonderful impressionist painting hidden in this cache which has increased about 30 fold in value over the last decade.

The Boston Museum of Fine Arts School had a rigorous and lengthy schedule in which draftsmanship was emphasized. This school flourished under the leadership of Edmund Tarbell and Frank Weston Benson and later under William McGregor Paxton and Joseph R. DeCamp. Some of their students went on to become famous artists in their own right, while others who were quite accomplished impressionists have not, to date, received the recognition they deserve. Tarbell, the acknowledged primary force, specialized in interior genre scenes and modified portraiture as did many of his students, especially the women who were referred to as "Tarbellites." A major example by Tarbell will now be priced well over one hundred thousand dollars, yet a good quality painting reflecting the same technical competence by one of his students my be acquired for several thousand and certainly under $25,000. Certain of the major works by these students remain with the descendants and in estates in the Boston area offering good acquisition opportunity. You can certainly find them on Newbury Street with a bit of effort and time. They appear from time to time up on the North Shore and at the ubiquitous country auctions.

The artistic legacy of Boston and its immediate environs is a very important one for the collector. From the early portraitists to the landscape artists of the mid-19th century, the luminists and marine painters as well as the more recent impressionists, artists receiving their training, artistic experience or having a residence in the Boston area have been among the leaders in American art. A majority of "The Ten" American painters had some connection with the Boston area even if it were a summer spent painting at Rockport, Gloucester, Ogunquit or at Provincetown.

The contributions of the early Boston sea and landscape painters such as Fitzhugh Lane or Martin Johnson Heade are universally recognized and expensive. Later, the Boston Museum of Fine Arts School flourished under first the leadership of Frank Weston Benson and Edmund Tarbell and subsequently William McGregor Paxton and Joseph Rodefer DeCamp. Travel Newbury Street to see examples and visit the collection at the Boston Museum of Fine Arts. This will orient you to both quality and price.

Boston's artistic statement was embellished by the fact that many of these artists were friends with the other male intellectuals of Boston society. As a group they became "arbiters of taste" with national and international influence, and among their closest friends were Henry and William James and Lilla

Cabot Perry. The poets and philosophers were also a part of this circle of great influence. In this scholarly and sophisticated milieu were very few women, and these were included by circumstances of birth or marriage such as Ellen Day Hale of that distinguished family. However, Boston was one of America's cities where women could study painting in a formal setting during that period. Proper housing was not available for those aspiring female artists. This meant that many of the students were local and this is where their works have remained.

Women artists in Boston could, indeed, receive adequate formal training in several recognized schools of the city. The most well known, however, was the Boston Museum of Fine Arts School (BMFA). As I have noted, following their experience in Paris, Tarbell and Benson returned to Boston and carefully organized a curriculum at the BMFA School that would duplicate their experience in France. They were particularly interested in their students receiving adequate fundamental training in draftsmanship and composition to enable them to produce interior genre works, which they favored, with competence as well as still lifes and landscapes of their native New England.

Certainly, students of the BMFA like Lee Lufkin Kaula, Mary Brewster Hazelton, Marguerite Steuber Pearson, and others created works that not only reflect the training at the BMFA School and impressionism but also demonstrate remarkable individual artistic skill. Much of the portraiture by these women became the modified portraiture characteristic of the works of Paxton and DeCamp who were the leaders of the BMFA School after Tarbell and Benson. These artists have been regarded as followers; in fact, a number were wives of other artists in the BMFA School. As I previously noted, they have been given the dubious title "Tarbellites." Their work has been traditionally judged as reflective of their mentors or derivative only of their experience. More recently, with the increased awareness of regionalism and public exposure of these students through exhibitions, monographs, and texts, the more unique quality of the artistic statement of these artists of the BMFA School has been appreciated. This has resulted in their inclusion in museum exhibitions and a rather marked escalation of the price of their works at auction as well as in the private sector. They still remain good values if they manifest quality in the context I have already discussed. I have seen and acquired works by Lee Lufkin Kaula, Ellen Day Hale, Gretchen Rogers, and Marguerite Pearson that would rival a Tarbell, Benson, or DeCamp.

Probably the most influential Boston female impressionist was Lilla Cabot Perry. She was a remarkable and resolute woman in every regard, managing to be a very supportive wife, mother of three girls, and an artist of great influence. In fact, this artist's contributions in popularizing impressionism for a conservative and skeptical American public have been widely appreciated,

almost obscuring the fact that she was an accomplished painter in her own right. While you will probably not be able to easily or inexpensively acquire a major work by her, some are in private collections and there is always the rare opportunity. I did acquire two from her descendants but only after a great deal of "leg work." Sometimes her small intimate landscapes turn up at auction and represent very good value. They are or can be as appealing as her modified portraiture. Hischl and Adler handled at least some of her estate and published a monograph. Mongerson Gallery in Chicago has a number of her works. She was treated to a retrospective by the National Museum of Women in the Arts. I had two examples in that exhibit and they were published in the text.

William Merritt Chase was not only one of America's great impressionists, but as a teacher and leader, he inspired a large number of artists to achieve success. Chase's paintings have simply reached acquisition costs far beyond the means of most collectors as have the examples of certain of his students. Other pupils however, can still be obtained at a rather modest outlay of funds. These pupils from the Art Students' League in New York and Chase's Summer School at Shinnecock created works of art that have many of the desirable qualities and aesthetic appeal of their mentor. With some diligence you can still acquire good examples for only a few thousand dollars. Chase was a figure of such importance that his students have been reasonably well-documented by the art historian Ron Pisano and others so that they can be easily identified with very little effort on your part. Thus, if a painting you are considering appears to reflect the qualities, style, and subject matter of one by Chase, then matching the signature with a student list will often permit documentation of the relationship. For example, the Nashville artist Edith Flisher studied with Chase. Being from that city I had seen a number of works by her that were competent but not exciting. A St. Louis dealer, however, showed me a still life that was magnificent and so Chase-like he must have been holding her hand. Needless to say I bought the painting at once.

Besides the formal schools such as the Pennsylvania Academy, the Art Students' League, the Chicago Art Institute, and the Boston Museum of Fine Arts School, there were art colonies active in the last decade of the 19th and first several decades of the 20th centuries. Certain of these colonies were under the leadership of a single famous artist like Chase's School at Shinnecock while others represented a gathering of kindred spirits. Even in the colonies of the later type, certain artists were dominant, influencing the lesser-known members. The close interaction between artists in these colonies elevated the general quality of paintings that were created in this environment. These colonies are very important to collectors and I will treat this subject in some depth later.

American impressionism, in my opinion, actually embraced a rather wide spectrum of styles and is not just a derivative adaptation of the sunlit fields or flower filled gardens of Giverny. In the 1910 — 1920 era, the color contrast employed by these artists became a bit more pronounced and the brushstrokes more delineated to construct the images of realism. This has also been given the rather all-inclusive term of "post-impressionism." Examples of this variation of American Impressionism have been traditionally less expensive than the more painterly works. This difference is not as great at present as it was just several years ago especially since the European post-impressionists have achieved such high auction prices.

A phenomenon that often causes fluctuations, or rather escalation of the price of paintings, is the public's fickle desire for a certain "look." As noted previously, among the most highly sought after paintings have been the ones that reflect the "Giverny look," often described as "a female in a garden surrounded by flowers." The scene is often illuminated by dappled sunlight. Artists such as Frederick Frieseke, Lawton Parker, and Richard E. Miller have become very expensive because their body of work has this appearance.

Almost any painting of this subject matter, executed with broken color, and employing a high key "blonde" palette should increase in value. Many lesser-known American artists created paintings with the characteristics demonstrated by those in Monet's circle. These paintings can often be acquired in the $10,000 to $15,000 range but should increase in value over time. As long as these works were executed in a painterly fashion and the perspective is good, the universal appeal of the subject matter makes these paintings desirable and a very good acquisition both aesthetically and financially.

An example of how a specific subject can be "in vogue" and affect collecting tastes and value is the price achieved by many of the "kimono" paintings. The use in paintings of "things Oriental," stimulated by a growing appreciation for Japanese woodblock prints, became popular from the last decade of the 19th century through the early 1920's. Especially popular was the Japanese female dress. In the 1980's, several articles appeared describing the virtues of these images. The La Femme exhibit arranged by Grand Central Gallery heightened public awareness of these works just at a time when Japanese buyers became interested in impressionism. This subject matter had obvious appeal to them. Thus, the stage was set for a sharp break in the slope of the acquisition price curve.

In the early 1980's, I acquired a major work (70" x 40") by J. Alden Weir entitled "Girl in a Kimono." It needed enough restoration and refurbishing of the frame to require a small risk on my part and some patience. The painting was shown publicly in the La Femme exhibit and placed on loan to the U.S. Embassy in Dublin as part of the Art in Embassies program of the U.S. State

Department. The subject matter is quite appealing and the painting received very positive reviews. Public exposure has greatly enhanced its value. I have been called by dealers, expressing great interest also in "Kimono" examples in my collection by Marguerite Pearson, Howard Hildebrant, Clifton Wheeler, William Chadwick, Lee Kaula, and Katherine Dreier (all of these works follow the same visual theme).

You can sometimes anticipate trends in art and employ intuitive knowledge of their development to acquire capital for what you believe to be prudent acquisitions. I have used American impressionist paintings to acquire other genre. Upgrading your collection is a journey with no ending and "in vogue" styles can be used as resources. For example, I have recently acquired good examples of portraiture by Gilbert Stuart, Rembrandt Peale, and Eastman Johnson which were essentially substituted in my collection in exchange for the funds from de-accession of a Lawton Parker "post-Giverny" impressionist piece. In another instance, I traded a large figural painting to a major New York gallery for a very expensive snow scene from the Woodstock School. They later priced the painting I traded that depicted two female figures for over $50,000 (my cost was $1,100), and if it sells for this the dealer will have realized a substantial profit. However, I acquired a painting (the snow scene) that I could not have easily afforded except by trade. Thus, you may be able to collect American impressionism even at inflated prices, but not necessarily in the traditional manner, i.e., in cash from an established dealer.

American impressionism is an excellent investment if you appreciate this art form, have an interest in learning about it and the "art world," guard against hysteria and fads, and are patient in your acquisitions. In the past two decades I have been fortunate in that I have not acquired many, if any, paintings that have decreased in value over the long haul. Some have increased in value dramatically without any anticipation on my part. In the late 1980's, I acquired a painting that is now probably worth over twenty times my acquisition cost because the artist was "discovered," but I bought it because of its technical quality and the subject matter. Some of the art I knew would increase in value because of an anticipated development such as a book about the genre or subject or an upcoming retrospective of the artist. After the Gerdts' regionalist American impressionism text and his book on Indiana painting, I had to reinsure my "Hoosier" collection, which by that time was being exhibited. After a tour of some 10 sites, I sold the collection intact to the oldest insurance company in Indiana because they respected my wishes regarding the preservation of the collection. I used the funds to complete my collection "The South 1840 - 1940."

There is no absolute success formula in acquiring American impressionist paintings inexpensively. Auctions can be hazardous and require adequate

preparation. Dealers sell for retail unless the work is not attractive for their particular clientele. So a "bargain" does not often come from these sources but a good value can. Private acquisitions from heirs are inherently time-consuming and a great assumption of risk by you. In addition, it should always be remembered that the commercial aspect of the American art world has its own measure of deceit, fraud, and litigation. In a true business sense, paintings are not liquid assets. Price determinations, authenticity, and condition are remarkably subjective, and you should be prepared to deal with these challenges and vicissitudes.

Can you still acquire examples of American impressionism that are aesthetically pleasing, representative of the qualities of the famous practitioners of this aesthetic, and are works that may someday greatly enhance in value? With some understanding of the American impressionist movement as well as alternative methods of acquisition that I have suggested, and a small token of courage, this can certainly be accomplished. Some investors in American impressionism will experience an incredible financial return on their investment, while, for others, the pleasure may be largely emotional. The aesthetic appreciation of impressionism is almost guaranteed. The rather substantial prices are also. Your challenge is to acquire these examples at a price you can afford. I have discussed several techniques by which you might well achieve your goal. Visions of finding a William Merritt Chase or a Frank Weston Benson at a country auction or in the bowels of an antique shop will assure that those chasing the dream American impressionist painting will always be there.

18
The Regionalists

I have discussed some of the art colonies and alluded to regionalism earlier in this text. Many have regarded the art colony phenomenon as the wellspring of regionalism, as often the major attraction for the artists was the compelling geography and the life-style they could enjoy in a particular setting. I would like to enlarge upon this topic because it offers real possibilities for the collector. I have collected examples from these regional colonies for some time and believe I have been rewarded for the decision to do so.

The type of environment often provided by the art colonies created circumstances in which pupil and mentor might often paint side by side rather than in an impersonal classroom setting. The skilled, but lesser-known artists would then be directly influenced by the leading figures of a particular school because of the daily intimate contact and prevailing spirit of collegiality. My unproven (aren't they all) theory is that the lesser artists benefited greatly by this intimate arrangement. The personal interaction with the great and famous was apparently inspiring. The opportunity for advice, counsel, and one-on-one instruction from more accomplished artists tended to ensure that the quality of work by the lesser-known regionalist was good and often reflected the skill of the more accomplished artists. These lesser-known members, whether inspired or instructed, produced works that mirror the quality as well as the creativity of the famous.

New Hope

The relationship of the New Hope colony to the Pennsylvania Academy of Fine Arts can almost be traced to a single artist, Edward Willis Redfield. His concept of painting *en plein air* in the snow and the "use of white as a color" influenced a generation of followers. Many members of this group, such as Daniel Garber, Rae Sloan Bredin, Elmer Schofield, Fern Coppage, and Walter Emerson Baum are very collectable; but there are also representative examples of Redfield's early work which are still affordable. They tend to be somewhat tonalist renderings rather than pure impressionism. The artistic merit of these examples, in my opinion, sometimes offers greater value than paintings by his followers that are equally expensive. I believe that Redfield was a major figure in American art because he influenced an entire generation of painters and introduced the idea of painting outside in the snow. The towns

around New Hope are quaint and the Buck's County area is lovely so, if you choose to go there in search of a bargain, your travels will be rewarded with scenic beauty if not an underpriced Daniel Garber.

Woodstock

Another colony of artists who emphasized snow scenes were those led by John Carlson as well as Alexander and Birge Harrison at Woodstock, New York. This regional movement was an outgrowth of the Art Students' League in New York City. Among the students of this group was John Bentley. His portrayals of snow scenes in a realistic style are a good example of the quality and subject matter that make the Woodstock group very desirable and collectable. Bentley and the Harrisons are still quite affordable and John Carlson's estate is handled by the Vose Gallery. I have never found a good example of the work of this group actually in Woodstock and the town has become a "tourist mecca."

Old Lyme

I have mentioned the Old Lyme Colony in other chapters but would like to offer some specific thoughts here. As Chase did, just before the turn of the century, H.W. Ranger, attempting to found an "American Barbizon," persuaded a group of artists to join him in the summer at the village of Old Lyme. These painters sought to establish an intimacy with the understated, agrarian landscape of the Connecticut lowlands and inland countryside. Many of the artists lived at the Griswold Mansion with "Miss Florence" Griswold. They used the mansion as a home base from which they would venture forth to the nearby rolling hills, the adjacent seashore, or the banks of the Lieutenant River. Back in the mansion they lived in apparent conviviality, engaging in lively discussions of all types of subjects including art, playing charades or pitching horseshoes, and always painting. This intimate contact between the artists seemed to enhance the quality of the paintings they created.

The Old Lyme group is especially collectable for several reasons. Those lesser-know artists living at the Griswold Mansion greatly benefited by the immediate presence of their mentors such as the leading proponents of impressionism, Childe Hassam and J. Alden Weir. The relationships of the artists were quite personal, and one can see the direct influence of the more famous members upon the lesser-known artists. I have had the opportunity to examine a large body of work by the Old Lyme artists in several estates including that of William Chadwick, handled by R.H. Love. Because of this exposure I have been greatly impressed with the uniformly good quality of the paintings. These less famous artists are not only technically competent but demonstrate a flair in depicting the phenomena of nature related to the coastline of Long Island Sound and the inland hills.

Because of the presence of Hassam and Weir, the activities of the Old Lyme group were fairly well documented during the first decade of the 20th century. Several recent retrospectives and exhibitions (especially the one of Connecticut Impressionism) have increased the exposure of works by the lesser-known artists and have increased the availability of examples. Auction houses and dealers have persuaded the descendants of these artists to offer portions or entire estates for sale. I believe that in the case of many artists, when a large body of paintings became available the technical skill and consistency of the painter could be appreciated, raising the confidence of collectors in acquiring works by them. William Chadwick was an excellent example. Chadwick lived in Old Lyme year-round, his wife was a Bancroft and they had substantial means, and he did not feel the need to exhibit so that his estate was a revelation.

Indiana

The artistic heritage of the state of Indiana is truly remarkable and, to many, unexpected. The legacy in the visual arts in that state has historical precedent. The Indianapolis School of Art was particularly active in 1877-79, over a decade before the 1893 Chicago Columbian Exposition. A significant and influential art publication, Modern Art, was begun in Indianapolis in 1890 and was considered one of the most influential American art periodicals of that time. In 1895 the art patron John Herron's estate was left to the city of Indianapolis and as a result, a full-fledged art school and repository for works of Indiana artist became possible. By 1906, the present Herron Museum was constructed.

A number of native sons such as T.C. Steele and William Forsyth went to Munich for their formal training and returned to establish a school of landscape painting in Indianapolis. The artistic style was Munich-inspired by tradition, but once these painters returned to Indiana they adopted whatever technique they felt was best suited to portray the natural beauty that surrounded them and many embraced a form of modified impressionism. These painters later developed a style which they felt enabled them to best depict the beauties of rural Indiana. What began as an introspective, mood-producing interpretation of nature became a vibrant and scintillating application of pigment with loosely-formed brushstrokes. These artists employed the high key, "white" movement — described by some as the "glare aesthetic." Several art historians have stated that the Indiana painters were actually the first regional group in America to work in the impressionist mode.

In 1897 Steele and his colleagues purchased the Butler house in the Indianapolis suburb of Brookville just beside the Whitewater River. Here they were able to create a form of outdoor landscape instruction not unlike the one their contemporary (and fellow Indianian), William Merritt Chase, had at

Shinnecock on Long Island. Under the mentorship of Steele, these artists were concerned with the presentation of that which was distinctly Indiana; the local color was their *raison d'etre*. They were the first group in the western United States to depict the local conditions in pure, clean color to delineate its natural charm. These Hoosier artists achieved a level of professionalism that went beyond the provincial and produced a sufficiently uniform but distinct style of painting that it could be fairly characterized as a school.

The Indiana art movement not only involved Indianapolis with its beginnings of urban development and its amenities of the state capital, but the small towns and villages of the state as well. Towards the end of the 19th century the artistic movement in Indiana was characterized by activity throughout the state. Many of the artists came from rural, small towns and villages because these isolated areas had an active community organization, such as the Federation of Women's Clubs, to support the arts. Richmond, a town of only 25,000, founded an art association in 1897, and the best known artist J.E. Bundy had an active school of instruction there at the turn of the century. Of the Richmond artists, Bundy, George Baker, and William Eyden achieved local and modest national fame for their work.

Forty miles south of Indianapolis Adolph Shulz found Brown County and the village of Nashville, its county seat, at the turn of the century. Shortly after 1900, T.C. Steele arrived with his second wife Selma, purchased over 200 acres west of Nashville and built a home, studio, and cottages for fellow artists. Adolph Shulz and his artist wife, Ada, came in 1907 to permanently settle in Nashville. Most of the Brown County artists lived in the village of Nashville and enjoyed the collegiality of residing in close proximity with others of like interests and activities. The Brown County Artists Guild became active in the early decades of this century and remains a viable entity to this day.

The Brown County Art Colony could be properly characterized as a phenomenon of nature. The nature was the allure of the the landscape around Nashville, with its wooded rolling hills and valleys populated with meandering creeks. In this farming community, fences, barns and wooden outbuildings abound. At certain times of day in the spring and summer a haze rests just above the tree line. This geography and atmospheric phenomena have been repeatedly portrayed by the Brown County impressionists and provide lovely examples of American landscape.

One of the pleasures you should aspire to in collecting paintings is to recognize the value of an artist or a particular style and to collect major examples before others appreciate these qualities. Then you can observe the growing interest of fellow collectors. The Indiana impressionists may still offer such an opportunity. Even more important, the level of artistic quality

is high, the subject matter is appealing, and the possibility of some independent scholarship on your part is real.

The South

For years the paintings by 19th century Southern artists were generally unknown and unappreciated outside the South. Many art historians were of the opinion that indigenous artistic expression in the South was limited to a few native portrait painters, migrant artists who depicted subjects of the region, or self-taught genre painters. Many described it as an artistic wasteland. As documentation of Southern manners and life-style, some of the so-called "Southern" works were deemed important as social statements, their artistic merit notwithstanding.

The South (and in some respects, the nation) has recently been made aware of this genre by the exhibitions arranged by the Virginia Museum of Art in Richmond and Art and Artists of the South: The Robert Coggins Collection, as well as the founding of the Morris Museum of Art in Augusta, GA. Historians Jesse Poesch and Buck Pennington have published excellent texts and certain dealers such as Rob Hicklen, Robert Mayo, and Dave Knoke, have had exhibitions, prepared brochures and catalogues, and published monographs that have greatly increased awareness as well. They need not be apologetic for their enthusiasm for art created in the South in the late 19th and early 20th centuries. Many examples of the work of these artists reflect few regional tendencies and have universal desirable qualities. Even more compelling are those images that particularly depict some unique characteristic of the life and times of the South.

As art collectors have become more aware of the quality and importance of the 19th and early 20th century Southern artists, many have incorporated several representative examples into their collections. I find these works compelling because of my own geographic bias and interest in Southern culture. Over the years I have collected with or noted the acquisitions by many of the Southern collectors such as the late Bob Coggins in Atlanta, Roger Houston Odgen in New Orleans, "Red" Blount in Montgomery, Walter Knestrich in Nashville, Jay Altameyer in Mobile, Jack Warner in Tuscaloosa, and others. I feel I have "discovered" several Southern artists and brought their work to the attention of others. The satisfaction of feeling you have made a contribution, however small, is still a pleasure.

In the 19th century it was fashionable for aspiring Southern artists to study at the Art Students' League and the National Academy of Design in New York, or the Pennsylvania Academy of Fine Arts before returning to their native South to ply their trade. The Corcoran School in Washington was also an opportunity. The South never enjoyed the phenomenon of established

schools of national and international acclaim (the Corcoran is an arguable exception). There were no art colonies that would rival those at Old Lyme, Woodstock, Shinnecock, or New Hope. There were however, a number of artists living and painting together in Savannah, New Orleans, and Charleston. Certainly, these artists benefitted from the shared knowledge and sometimes diverse experience of the members of their group. Some traveled widely to acquire their skills, such as Hattie Saussy who trained at the New York School of Fine Arts, the National Academy of Design, the Art Students' League, and the Academe Julian in Paris. Others remained at home, often engaged in altogether another occupation, such as Christopher P.H. Murphy of Savannah, who was a ship's chandler and had a quick look at a watercolor exhibition by John Singer Sargent as his formal training. He was a very accomplished watercolorist, however.

The Charleston artists were never an official group but the leaders Alfred Hutty, Elizabeth O'Neil Verner, Anna Heyward Taylor, and Alice Ravenel Huger Smith certainly seemed to share their knowledge. Other artists working contemporaneously in Charleston include several notables: Edward Harleston (a free, black artist), Virginia Chisolm, Rufus Zogbaum, Charles Bryan, Emma Gilchrist, Mae Paine, and Eola Willis. Often they improved their work through mutual critique and analysis without the benefit of formal training. A number of these artists painted portraits on commission for their livelihood while executing other paintings of different subject matter, such as landscapes and genre works, as evidence of their own self-expression. Many taught in the fledgling Southern art schools. During their vacations, they painted while travelling throughout the South. In the summer they might join artists ᶠᵒom other schools such as the Art Institute of Chicago in the North Carolina mountains.

Most of these artists painted traditional landscapes, but a few embraced elements of both luminism and tonalism. The latter method of pigment application was particularly well-suited to the depiction of atmospheric conditions of the lowland South with its unique moist humid climate, moss-laden trees, and the mixture of diminished sunlight and fog in the swamps and bayous. Some Southern artists of the 19th and early 20th centuries maintained residences in both the North and South. Their work in each location often reflected the environment and the colleagues with whom they were associated. Occasionally, you will find paintings reminiscent of the style of a presumably Northern mentor yet depicting the subject matter of the Southern region.

Women were among the most talented but, for a long period of time, least recognized Southern artists. Although some of the 19th century female Southern artists had a local following, many painted largely for their own self-

expression. Nonetheless, these women are now receiving the acclaim they so richly deserved during their lifetime. Often, their draftsmanship was excellent, as they were academically trained. Their sensitivity for certain subjects have made works by these women particularly compelling and very collectable. There were two large groups of women artists in Charleston and Savannah but the others painted in more isolated circumstances. In Charleston, the best known were Elizabeth O'Neil Verner, Alice Ravenel Huger Smith, and Anna Heyward Taylor. However, Eola Willis, Virginia Chisolm, Mae Paine, Emma Gilchrist, and another half dozen are very collectible if you can locate them.

Hutty, Smith, and Verner tend to fetch reasonably high prices, especially in the local market, but the others do not. Finding Southern paintings is a real challenge and you must have great patience, a good road map (Nebo might not be on it but Tryon is), and a small perfidy to gain entry into the homes of some good ole' boys — and gals. Now some dealers like Rob Hicklin, Dave Knoke, Bob Mayo, or Taylor Clark will be glad to do it for you, for a price. As additional emphasis and scholarship is applied to this area of American artistic tradition, the value of the contribution of Southern artists will be increasingly recognized.

While there are certainly other prominent regionalist groups, including the Rockport, MA artists, the Ozark and Silvermine painters, several Western groups, and the California impressionists; those I have discussed are clearly identifiable from a stylistic viewpoint and better known to me. Also, examples of these artists may remain in the region of their origin and may be acquired privately. They can sometimes be purchased, if found, inexpensively elsewhere because the value of these works is unappreciated, especially outside the local region. The quality of the examples is often high for reasons previously discussed, and a collection of regionalist works from different colonies can provide variety and visual appeal. Major examples can be acquired because they are available, adding to the overall importance of your collection from an aesthetic perspective. You can also have a bit of the sense of adventure and the satisfaction of engaging in an acquisition mode that is definitely creative by collecting the art from a clearly identifiable region, chosen by you.

19
Works on Paper

While I have described other affordable alternatives in collecting paintings such as acquiring major examples by the students of the most famous artists, collecting paintings from recognized schools and colonies of artists, and paintings which are representative of the famous artists but need to be refurbished or restored, I would also suggest that works on paper be considered as a collecting strategy, especially if your goal is to have technically as well as aesthetically good examples of the expensive and highly acclaimed artists.

A decade or so ago, many artists who have since become almost unaffordable and rare (if you want an example of good quality) were, and possibly still are, available as works on paper at prices most of us will be able to manage. This may no longer be the case for all, and combined with the Tax Reform Act of 1986, the savings and loan debacle, bank failures, the Alternative Minimum Tax, the Yen backed by "yen," and Chapter 11 and 7 (not in the "Good Book"); one can understand the auction house and private dealer comment "good paintings are very expensive; lesser examples are hard to sell." In effect, this says that you can get a bargain on an undesirable painting, but as I have repeatedly noted the validity of this statement depends on one's definition of a bargain. I will repeat for emphasis, if the painting does not represent the qualities that made that artist or genre famous or desirable, then the example before you is not a bargain at any price because it violates my first principle — the absolute insistence upon quality. This criterion must be so sacrosanct that you should not be tempted to compromise to "the realities of economics and availability." If you cannot afford a good example of any genre or artist, do not buy one and if it seems like a bargain, be careful.

Conventional wisdom has been that works on paper were often a less than substantial or serious effort by an artist to create an image. Many collectors believe that works on paper often represent studies in preparation for a more important oil on canvas versions of the image or are simple attempts to arrive at a preliminary evaluation of how the more demanding oil will appear. The common statement by collectors "all I have is a watercolor (pastel, pen and ink, pencil drawing) by _____" (fill in the famous name) is a telling comment and reflects what I know to be an unjustified bias. Send me all the *inexpensive*

watercolors by Winslow Homer, John Singer Sargent, or Maurice Prendergast and I will definitely take them off your hands.

Interestingly, in recent years the canons of prudent collecting have been relaxed, and I think correctly so. I can recall when the pastels of Edmund Tarbell sold for only a small fraction of one of his oils, even of the same subject. By definition, a pastel on paper or any other form of support was not believed to be as desirable as an oil. They were simply considered such lesser examples of his efforts that few collectors (hence dealers) showed any significant interest in them. Would it be sensible to collect the works of artists who worked primarily in pastels like Glen Cooper Henshaw or Mary Cassatt and not have some inkling that Tarbell's pastels might also demonstrate his draftsmanship and the painterly qualities that made him an acknowledged leader of the Boston Museum of Fine Arts School? Frank Weston Benson was said, by several well-known dealers and at least one credible scholar several years ago, to have "never" (or almost never) composed pastel works. This statement reflects the fact that they had either not seen one, dismissed the examples shown to them out of hand as forgeries, or simply failed to reason that Benson may have completed or sold only a few pastels. Several years later, however, a cache of "rare" Benson pastels was uncovered. It is now conceded that he indeed did pastels and that they are desirable, especially for someone entering the "pricey" market of the Boston Museum of Fine Arts School. In fact, his most characteristic genre of modified portraiture lends itself readily to this medium.

The watercolor, to many collectors, is not a serious undertaking because it cannot be as extensively reworked and refined, as can an oil painting. The corollary to this, in the minds of many is that the artist attempts to make the effort simple in order to minimize the chances of an untoward result — the "do little" plan of composition. However, painterly qualities are often demonstrated quite effectively with watercolors, and mixed media or gouache will allow not only the juxtaposition of color contrasts but the embodiment of texture as well. If the watercolors of a Maurice Prendergast demonstrate his talent, why cannot those of other less expensive or less well-known artists? I personally would rather own a William Merritt Chase watercolor landscape or interior genre painting than most of his oil on canvas renderings of Pisces displayed as corpus de lecti (dead carp).

Certainly, topographic paintings executed on location with pen and ink, watercolor, or pencil on paper are more effective and certainly more spontaneous than a reconstruction of the image by the artist in oil (or whatever medium) at some later date. The Civil War was documented by wonderful visual images done on paper, and those are highly collectable — a fact well accepted between scholars, collectors, and dealers. Somehow the recognized

value of documentary works on paper is still not translated to a more generic appreciation of these images, however.

I should interject a caveat, and that is related to conservation and restoration. Just as pastels and watercolors are difficult to rework, one is somewhat constrained by what can be done with a work on paper that is in poor condition or has been damaged. You should be very cautious in acquiring these works if you have any reservations about the condition. Conservation or restoration of these works will require an individual specifically trained for this purpose, a "paper conservator." Some conservators will refuse to accept works on paper. Prior to acquisition you should seek an opinion if there is any doubt regarding condition of the work on paper or the projected cost of restoration. You should know the multiple varieties of mold that find this such a wonderful culture media. Do know what "foxing" is? You do not ride to this in red jackets. Conservation of works on paper is a very specialized circumstance and it will be quite productive for you to become aware of the basics. I have been very pleased with the results of removing acid stains or a bit of brown discoloration on a modest purchase that became a major work.

As a collector, works on paper should be regarded not as a compromise but as an alternative — one that I believe has the potential for significant rewards. When I exhibit my collection "Works of the South on Paper," I offer no apologies.

20
Appraisals

Most collectors do not devote sufficient attention to the valuation of their paintings, especially considering the importance of this in the overall scheme of things. Often the actual current value of a painting is not reflected by any proper documentation held by the collector. This can lead to a variety of dire consequences. If you are a naive and unwitting collector, you can incur significant financial and legal risks by participating in a flawed appraisal procedure. Many problems can arise as the result of a valuation that does not reflect a fair market value for a painting. These problems can be largely avoided by certain prudent and practical measures.

Legally, the appraised value of a painting should reflect "that amount which a willing buyer would be prepared to pay a willing seller, neither acting under coercion or duress." This should represent the full market value based upon a specific instance of supply and demand — the historical market forces that have traditionally served the free enterprise system well. While this appears simple and direct on the surface, arrival at a fair market value acceptable by all potential parties can range from problematical to extremely difficult in the art world.

In theory, all appraisals should be the same regardless of the motivation for obtaining one, but often they are not. Whether the appraisal is requested for insurance purposes, an anticipated donation, or an impending sale will usually influence the behavior of the collector and the appraiser as well. This can create a bias on the part of both parties, be it intentional or unconscious. You can avoid this potential problem by never revealing to the appraiser the future implications of the transaction, but this is often difficult to do.

Television has probably done little to educate the American public, but in one area it seems to have had a profound influence, and that is upon our concept of impropriety. The appearance of impropriety should be avoided by a collector just as much as an investment broker, a U.S. Senator, a savings and loan officer, a television evangelist, or a presidential candidate. In fact, the appraiser must not only act at arm's length but must appear to do so as well. Both you and your appraiser must conduct yourselves in an honest and proper manner and be so circumspect that it is *obvious* you are honest and proper. Any

element of implied bias, self-serving action, or outright conspiracy or collusion must be eliminated from the transaction.

Your appraiser must have no commercial interest in the action, except a fee for the service provided. The appraiser must not have been a part of the acquisition of the work or works to be appraised. Thus, the dealer who sold you the painting should never appraise it for any purpose. Additionally, the compensation of the appraiser should not be related to the valuation of the appraisal. Stated in another manner, it is improper for an appraiser to charge a percentage of the valuation as their fee. Interestingly, this is the traditional manner of compensation for an appraisal in Europe and was utilized in the United States until several deliberative bodies, including the Internal Revenue Service, decided that such an arrangement provided too great a temptation for an over-appraisal, thereby deeming this practice improper. I agree. If you look upon it another way, it probably takes less time to appraise a William Merritt Chase or Edmund Tarbell than a painting by one of their obscure pupils, a painting with a lower market value.

After the Tax Reform Act of 1986 and subsequent unfavorable rulings of the IRS, museums experienced a significant decrease in "gifts of kind" from collectors because the financial incentives for their generosity were less. Alternatives including the sale of their paintings at substantial profits, disincentives such as forms, regulations for documentation, and the implications for the alternative minimum tax were a source of bewilderment and anxiety. As an inducement, museums might occasionally imply to a collector that they could arrange for a "very favorable appraisal" should the work be a proffered gift. You as the potential donor should politely refuse. Donating paintings is a rewarding and pleasurable activity and you can do it correctly and still experience the significant and appropriate benefits.

In computing tax relief or insurance claims, artificially inflated appraisals are not only dishonest, but the risk of monetary and legal penalties also exists. Some appraisers still engage in this practice, and if you are offered the opportunity to participate, you should steadfastly decline, irrespective of the intent of the appraisal. Additionally, if a dealer offers you a painting for acquisition stating that they can assure you an appraisal much higher than the purchase price, do not succumb to the temptation, because, by definition, this appraisal will not represent "fair market value."

Selection of an appraiser is, at best, an inexact science. It is impossible for a collector, curator or art historian to have expertise in every era, style, or movement in art. Therefore, you should anticipate that appraisers also have limits in their knowledge in the valuation of paintings. You should select an appraiser who has specific expertise and experience with the particular genre and style of the paintings you are requesting them to evaluate. Appraisers

enter the field from a variety of backgrounds and experience. Some have classical training in art history and may have had experience as curators and museum administrators before entering into a more commercial environment. These appraisers may have great knowledge of the importance of a painting but little appreciation of its monetary value. Appraisers who have little formal art education but much more experience in auction galleries and commercial firms will usually know the wholesale and retail value of a painting. They also often have a very good idea about the effect of condition upon its value.

There are several accrediting bodies that will tell you that the appraiser has successfully completed a prescribed period of study and has passed a certifying examination. Determination of that appraiser's qualification to evaluate a specific painting or art object will require that you obtain biographic data from the potential appraiser, or to seek the opinion of others. I have found it useful to inquire of museums that have collections featuring the work of the artists I collect or painters related by their work, subject or training for recommendations. Also, your dealer will often suggest, as appraisers, other dealers in the same field whom they believe to be expert and reputable.

Once the appraisal has been obtained, you must insist upon proper documentation of the process and adequate justification of the conclusions of the appraiser. The document must convincingly demonstrate the personal, studied analysis by your appraiser, the lack of undue influence or duress in the process, the authenticity and condition of the painting, and a statement about the artist. Some appraisers have elegant and very professional appraisal forms, while others may inscribe their thoughts upon a sheet with only their letterhead. However, from the collector's viewpoint, it is the content of the appraisal that is important and not the form.

Thus far I have emphasized the non-participation or constrained participation of collectors, but this is not meant to infer that you should adopt the posture of passive submission in the appraisal process. You should have some idea, at all times, of at least an approximate value of what you own. You can chart the prices achieved by similar paintings at auction, much as you follow the fortunes of your favorite stock or commodity, for that matter. This will give you some idea of the fair market value of your painting. You can ask for a quotation of the price of a similar work by the artist that you find published in an art magazine or periodical. This will give you the retail price. I would add a caveat however, that when using this method of establishing or confirming fair market value, you should be convinced that these paintings are equivalent in quality and importance; a generic comparison has almost no validity. If you have a great Robert Henri and the dealer a minor example, the price comparison will not be useful. The difference in value for a sketch and a major work by the same artist can be a very large multiple and the IRS panel

knows this, so will your dealer or fellow collector when you are making a trade. My advice is to let your appraiser make a determination and if you do not agree, discuss it then. If, for whatever reason, you are still dissatisfied with the valuation by the appraiser, you should seek a second opinion.

As an axiom, if an appraisal accurately reflects the current marketplace value of a painting, it will be useful for almost any conceivable purpose. The collector, museum, insurance company, and IRS will be best served if this procedure is conducted with integrity.

21
The Disposition of Your Paintings

This chapter probably goes further than most of us as collectors wish to pursue this subject. There are proper known methods for your disposition of a painting or paintings at the time of death and I will discuss those here. If you plan to donate all your paintings during your lifetime or take them with you into the hereafter, do not read this chapter — but have your CPA, personal guru, or your hairdresser do so.

Often we are so involved in the acquisition process that we simply do not devote a great deal of effort to the mechanics of de-accession or disposition in the form of outright gift, permanent loan, or transfer by a trust instrument of our collection. You should be aware of the necessary documentation as well as the legalities involved in order to assure that your wishes are subsequently met. Your paintings mean a lot to you and if you consider their possible fates you will find out how much you care.

In most instances, a painting will be conveyed as a specific bequest. If a painting is specifically bequeathed, your will or legal instrument should expressly address how the expenses and taxes are to be paid. In certain states, title will invest in the legatee as of your date of death. The bequeathed painting will generally not be applied to pay creditors until the residue and general legacies have been exhausted. In other words, the benefit occurs at that time. If the painting has been damaged or stolen prior to your death, the legatee is entitled to the proceeds from the insurance. For this reason, you should be certain that your appraisals are reasonably current and they should represent fair market value for your paintings. Liens and litigation involving your paintings will become the responsibility of the legatee unless your will directs that such costs and expenses are paid out of the residuary estate.

Should you wish to leave paintings to your spouse, funding through the marital deduction will allow a painting or paintings to escape taxation in the estate. There are several new entities that will allow the postponement, if not the escape, of taxes.

If you wish to have a painting in a qualified terminable interest property (QTIP) trust, the painting can also be used to fund the trust. Although a painting will not generate income, it can be a substantial part of a trust. Treasury Regulations note that "a power to retain trust assets which consist

substantially of non-income property will not disqualify the interest if the trust requires that the trustee convert the property to income or liquid assets within a reasonable time." The reason for this qualification is that the sale of paintings is often a prolonged process, and to dispose of a painting under duress often means that it may well be sold below its market value. Thus, you are given time to ascertain fair market value.

In order to qualify for a QTIP trust, your spouse must have the use of the painting and can fully direct its sale. Often, if your surviving spouse wishes, they can, under the terms of your will, hold, exhibit, and enjoy a painting while it hopefully increases in value with time rather than be required to have the painting sold soon after your death.

Because of the speculative nature of the art market and the downside risk of holding a painting, an appointed trustee if not your spouse should be expressly authorized to retain a painting or collection, but subject to the surviving spouse's right to request the de-accession of the work or collection. Also, the trustee should be exonerated from any loss incurred as a result of this retention. In most states, any provision in a will exonerating an executor or testamentary trustee for failure to exercise reasonable care, diligence, and prudence is contrary to public policy and is thus void. So ask your attorney for a landmark case, a well-known one, if the facts are in order not to jeopardize the marital deduction benefit. For example, the court limited the application of a will provision, authorizing the executors to sell a $40 million collection of rare books as an entirety or in parts for "less than full market value" to a non-QTIP property. This is an extreme case and would not apply for most of us — Benjamin Franklin's diary notwithstanding.

Because of art's nonproductivity in generating income and cash flow, when a painting is held for more than a year in an estate or trust and then sold, the proceeds may be treated for tax purposes as not only principal but also as delayed income. The Uniform Principal and Income Act, adopted in most areas, states that: "the sum allocated as delayed income is the difference between the net proceeds and the amount which, had it been invested at simple interest at [4%] per year while the property was underproductive, would have produced the net proceeds less any carrying charges and expenses previously charged against income, such as restoration and insurance." Let the legal eagles ponder that one.

The tax allocation provision of your will should be given particular attention by your tax or estate attorney if your estate has valuable paintings. If a valuable (or potentially valuable) painting or collection will be specifi-cally bequeathed (and if there will be no offsetting marital or charitable deduction), a tax clause or statute that directs the payment of all estate and other death taxes out of the residue could eliminate a substantial portion of the

residuary disposition. If the painting is held in a revocable trust or if an irrevocable grantor retained interest trust that is includible in the grantor's gross estate, the same result may obtain. This could give you a significant problem with the allocation of your painting assets.

This tax apportionment problem could be exacerbated if there is a great increase in the value of your collection between the time your will is drawn in relation to your date of death. This has certainly happened in the last 15 years with American paintings of the 19th and early 20th centuries and you may unwittingly leave your heirs a problem if you do not take this into account. For example, you bequeath a painting to your son or daughter and direct that all estate taxes on property passing under your will be paid from the residue. You leave the residuary estate in a QTIP trust to your spouse, but by the time of your death, the painting has quadrupled in value. The estate taxes would then substantially reduce your marital residuary gift in this particular circumstance. Your spouse may realize very little or even nothing from the painting — unless they exercise their right of election and thereafter disinherit the children — not a result foreseen by you or your children. In many cases, estate taxes should be apportioned against a painting or the trust holding the painting. What you need to do is tell your attorney what you wish to achieve and have them prepare the documents that will accomplish this goal.

You should ask your attorney these questions: How might the taxes resulting from your bequest be paid without the necessity of de-accessing a certain painting or a group of your treasured acquisitions? Might there be made available resources from insurance that can be used for this purpose? Is the beneficiary of the insurance policy also the person or trust that will receive the painting or bear the responsibility for the taxes? Should the estate taxes on the insurance be allocated against the proceeds from the insurance? Does the beneficiary or trust have other resources or borrowing power, so that the beneficiary or trust has the option of borrowing funds to pay the estate taxes? These alternatives can only be considered if a carefully orchestrated disposition plan has been previously thought out by you.

If there are few or no liquid assets in an estate and, in order to preserve the art collection, administrative expenses are paid out of income and deductions taken on the fiduciary return, the value of the residuary bequest to the charity or spouse will nevertheless be reduced by these expenses. If the expenses are chargeable to principle under local law and the decedent did not otherwise provide and alternative method, this is especially applicable. This says if you do not provide funds for expenses, some of your paintings may be sold under duress to raise capital for the retention of others.

Your collection can be incorporated like a business so that the payment of estate taxes can be deferred under estate law. Deferral in this circumstance

would enable your family to choose to retain the paintings for possible appreciation of their value in a rising market. The consents of the beneficiaries obtained as to the retention of art could be speculative, the art market could decline and leave your fiduciary at risk of a surcharge claim. Whether the possession and use of the paintings by the shareholder constitute a dividend and/or generates income to the corporation is an interpretive risk by the IRS that must also be considered a potential problem by you.

The location of your paintings at the time of death may indeed have tax consequences. State death taxes are usually imposed on paintings by the state in which the works are physically located at the date of death. This could present planning opportunities for you to minimize state death taxes on a valuable work or collection by locating the paintings in a state with only a "pickup" estate tax equal to the amount of the federal credit. If a painting is on exhibit in a not-for-profit museum in a state other than your domicile, the work may be exempt from the death tax of the state where the object is being exhibited as in the estate of a nonresident.

If your estate involves a sizable art collection and the executor has no expertise in that regard, you may provide for the appointment of an art advisor. This advisor can make decisions concerning the sale or retention and conservation of your collection. The exercise of authority by advisors appointed by your will to direct the coexecutors if there is a disagreement can be upheld over the objections of one of the coexecutors, and in the case of Matter of Rubin. Your advisor should be then considered a fiduciary of the estate and the coexecutors will not be personally liable for losses if they follow the directions of the advisor. Rubin also held that the directions of the advisors are not subject to the court's review in the absence of improper motive. The question of compensation for the advisor should be addressed in your will or settled by an *inter vivos* agreement between you and the art advisor.

The nominated executor of your estate should ascertain whether the works of art are secure in their location and should expedite the issuance of letters of testamentary. An itemized appraisal should be arranged as soon as reasonable following your death. Obtaining an accurate and timely appraisal of the works is of great importance and should be done by an expert in that specific area of art. The provenance and exhibition record should be documented, as these data can often enhance the value of a painting.

If the federal estate tax return is audited, the IRS will probably, as a matter of course, submit works valued in excess of $20,000 to the IRS Art Advisory Panel for valuation. The Art Advisory Panel is not told whether the work of art is being valued for income, gift, or estate purposes. Your executor should also evaluate the adequacy of the insurance coverage and obtain a rider to the insurance policy, covering the interest of the estate and the beneficiaries. At

the time of death, art collections are often underinsured and appraisals are often outdated. You should make certain yours is not.

The executor should ascertain whether anyone other than the decedent has a fractional or remainder interest, a security interest or any other interest in any of the paintings. Collectors sometimes purchase major examples jointly. If a painting has not been properly characterized, the family may not be aware that earlier a museum had been given a remainder interest in the work and that at the time of your death the painting or paintings should be properly delivered to the museum. Whether a painting represented a loan or a gift has often been confused and can be the subject of somewhat lengthy and hostile litigation, tried in the newspapers.

Remember the clamor over the sale of the Wyeths by the owner when a museum did not appreciate the meaning of a "long term loan." The legal language of the transfer clearly (to a legal authority) made it a long term loan and not a gift. Many administrators and board members may not understand the difference, but they should and you should assume the responsibility that they do in your case. If your entire collection or a single painting is to be sold by the estate, it is important that the manner of disposition be arranged to achieve the fair market value of the objects and that any conflicts of interest be avoided. In the Matter of Rothko, contracts for the sale of 798 paintings made by the executors of the estate of the famous colorist Mark Rothko through Marlborough A.G. were voided because of conflicts of interest.

One of the three executors was an officer and director of Marlborough Galleries, and another executor was an artist whom Marlborough represented. These two executors, along with Marlborough Galleries, were surcharged for appreciation damages of more than $7 million based on the value of the paintings at the time of the decision. A third executor was surcharged for the loss incurred at the time of the sale because of failure to exercise "prudence" (avoid errors of the p's — prudence, parsimony, and propriety). Certainly, this case is extraordinary in the financial implications involved, but the circumstance of conflict of interest is not that unusual.

If your paintings are to be auctioned, depending on their quality, the executor often can negotiate certain terms of the sale with the auction house. The auction house can waive the sellers 10% fee, the advertisement publication costs, and guarantee your executor a minimum price. For valuable, prestigious works, such terms are almost always possible. While this is not the standard business practice of most auction firms, this is done as an exception to secure the inclusion of important works to enhance the specific auction as well as the image and standing of the auction house. If a single painting is particularly valuable, your executor can arrange for the auction house to have it placed as a color illustration in several publications, thereby greatly

increasing public awareness and presumably interest in purchasing it. If you believe that the cover illustration of the advertisement of the sale in Antiques or Art in America are chosen at random — I have a bridge I want to sell you.

If your paintings are on loan to a museum, your executor should request their return at your death or confirm the loan status and notify the museum of the estate's intent to preserve its interest in the property. If the painting is to remain on loan, your executor should notify the museum of changes of address or changes in ownership. Timeliness in discharge of this responsibility is of the essence. In Redmond v. New Jersey Historical Society, the court held that the statute of limitation did not start until there had been a demand and refusal to return the loaned object. The issue in this case was a portrait by Gilbert Stuart on loan to the New Jersey Historical Society for more than 50 years. An "old loan" statute in one of approximately 20 states can pass title in the loaned object to the museum on a deemed gift, abandonment, or statue of limitations theory. These statutes generally apply to an indefinite loan (or a loan for a definite period which has expired) to a museum, where the lender is unknown, cannot be contacted, or where there has been no written contact with the lender for a stated period. Notice to the institution is usually required, and the lender is given a reasonable period of time to retrieve the loaned object from the museum. If the object is not retrieved during that period, title of the object will generally pass to the museum.

If a work was stolen or is lost for unknown reasons before your death, or is discovered missing in the course of the administration of the estate, the theft should be reported to the proper authorities, the Art Dealer's Association or other appropriate bodies, and a stolen art archive such as the International Foundation for Art Research (IFAR). Efforts to locate the art should be continuous, so that the cause of action to recover the work when it is located will not be time-barred or barred by states applying a discovery or demand and refusal rule.

A claim by you or your heirs for the recovery of an allegedly stolen work may not be brought for decades. The statute of limitations in a replevin action (often three or four years) may start to run at the time of the good faith purchase, because the purchaser is treated as a "converter." The New Jersey Supreme Court in O'Keefe v. Snyder applied the discovery rule, holding that the cause of action does not accrue until the owner, exercising due diligence discovers, or should have discovered, the whereabouts of the stolen work. Once the limitation period expires, O'Keefe held that title passes to the good faith purchaser.

If an estate has a claim for breach of warranty of authenticity — because the "Monet" is a fake — the executors should investigate initiating legal action immediately. Actions for breach of warranty of authenticity normally

accrue at the time of sale. In <u>Wilson v. Hammer Holding, Inc.</u>, an action for breach of warranty that a painting was a "Vuillard" was instituted more than 25 years after the purchase was ruled to be time-barred. In <u>Rosen v. Spanierman</u>, the court held that a cause of action for breach of an express warranty of authenticity that a painting was a "John Singer Sargent" accrued at the time of sale (in 1968) was barred by the four year statute of limitations. Obviously, there are no specific guidelines with regard to the timeliness of reporting, due notice, or for the initiation of causes of action. However, the temporal proximity greatly enhances a positive outcome. Sometimes collectors will never really investigate the authenticity of a painting but this can become an issue during valuation at the time of death. So know what you have.

Planning for the testamentary disposition and administration of art necessitates that you obtain documentary information and record of the artworks, and that you provide for the security and preservation of the collection. The rights of all co-owners holding the remainder or undivided interest in the paintings should be documented. Special attention should be given to your estate, gift and income tax by generation delaying legal instruments, treatment of the transfer, and the payment and allocation of such taxes at your death.

Testamentary disposition of paintings requires professional legal advice but also your involvement to assure that your desires are respected. While general legal principles of ownership transfer and inheritance statutes will serve as benchmarks, there are nuances that may have to do with unique relationships of you and art institutions, you and appraisers and dealers, and you and your advisors that often require the special and specific expertise of persons outside the legal profession. Collaboration, in which you combine expertise and wisdom from several disciplines, I believe is the most appropriate manner to assure the proper testamentary deposition. You have a responsibility to yourself as a collector to make certain your acquisitions achieve your purposes even after you have passed to that larger museum in the sky.

22
Can Collecting Paintings Be Hazardous to Your Health?

The acquisition of objects of value has many compelling features. These range from the satisfaction you gain from the ownership of your collection to enabling your entry into valued intellectual and social circles. Curators, art historians, and some fellow collectors often extol the virtues of collecting in their public pronouncements and in the literature. I trust I have conveyed my own pleasure from this process.

As I have previously discussed, the acquisition endeavor itself can be very stimulating and the entire process rewarding. Appreciating and sharing your collection can certainly be a most pleasurable experience. Many people will deem you affluent and possessing good taste. Various art and financial publications have periodically emphasized the vast sums of money that have been made from the sale of individual paintings and the general increase in value for certain schools or groups of artists. After all, a profit of about $42 million in less than a decade for a single Picasso or the prices fetched by VanGogh's (try $87 million plus premium) and Cezanne's works are more than simply newsworthy. They may well have affected the traditional standards and even the codes of conduct in the art world. These revelations have certainly changed public perception about art and art collectors.

In considering this latter phenomenon, you should also realize that market forces in the art world have their own unique reactions to supply and demand. Because this is a treasured rather than utilitarian object, the demand can be artificially manipulated to a much greater extent than in the standard commercial world of responding to the marketplace. The perception of rarity can be manipulated, especially with artists who are deceased. Value not only depends upon these variables but to a large extent upon whether the painting demonstrates the genius of that particular artist or the school that it represents. I have discussed these valuations in previous chapters but I think these deserve repetition as they create the environment or context of this discussion.

You must understand that you are in an emotion-laden environment, acquiring objects whose authenticity, condition, and typicality are based upon opinions. There is little scientific data involving, at times, rather large sums of money. Although the art world is not unique in this regard, it does involve the largest and most fragile of egos, except for possibly the world of entertainment

or, in my own experience, academic medicine. A milieu composed of emotional volatility, a paucity of objective data, large sums of money, and proud (sometimes unreasonable) people, could prove to be a combination that just might be hazardous to your health. Can you practice preventive medicine to diminish the emotional and financial stress? Can you avoid some of the more obvious pitfalls, and can you balance the risks with the benefits? These are my intended subjects of this discussion.

Knowledge is power. Experience is one way to gain knowledge, but the pathway is long and arduous and the tuition can be very expensive. Purchasing a fake painting is a very traumatic way to learn about fakes. Instead, you should acquire enough knowledge so that you can identify a representative example of an artist's work and, at least, identify an obvious fake. You should do this by deciding on the kind of art you want to have and then seeing as many examples of this style or group of artists practicing as you can in museums, galleries, and collections. Read everything you can get your hands on; devour what has been written within your reasoned time allocation for this endeavor.

Armed with this body of data, you can also make another very important choice, that of choosing a mentor. Mentors are the art equivalent of the legal expert witness: they assist in the search for the truth. Mentors can be fellow collectors, art historians, dealers, or "consultants" (although I am not certain what this term means in contemporary American life). Your mentors can change as your own tastes become more refined, your resources change, and as your collection matures. I will use several personal references that may be helpful.

I have had a number of mentors, but several of the first were the most determinative. As I was living in Boston, the paintings of the Boston Museum of Fine Arts became so familiar to me that a stroll down Newbury Street was a natural extension of this experience. I was able to first interact with Vose Gallery and especially having a mentor like Robert C. Vose, Jr. was a fortunate circumstance for me. Due to financial limitations, I was certainly not in the market for a Fitz Hugh Lane or a Martin Johnson Heade. In fact, the artists I liked best (Edmund Tarbell, Frank Benson, Joseph DeCamp, and William M. Paxton) were almost beyond my means. I know a large number of collectors who find themselves at this juncture and are made to feel inadequate if they do not exercise "courage" and financially "reach" to acquire museum examples. This attitude, if taken by your freshly chosen mentor, can be very hazardous to both your physical and fiscal health. Bob Vose guided me to consider major paintings by lesser-known artist which were of good quality. This was when I first acquired great examples representing the best of the graduates of the Boston Museum of Fine Arts School and former students of Tarbell, Benson, DeCamp, and Paxton.

The acquisition of these examples allowed me to achieve several things simultaneously: to obtain the best works of these artists, collect enough examples to truly have a collection of substance that made an artistic statement, and stay within a financial commitment I could accommodate. This avoided tachycardia, night sweats, and possibly delusions of grandeur. This also lessened the probability of my acquiring a fake or misrepresentation because the profit would not make it worth the perpetrator's risk. There was simply not enough money involved to make this kind of perfidy, cum malfeasance worthwhile.

You might think about how to practice a bit of prevention. First you should choose a dealer who is known to the trade, who has been in the business in some capacity for a while, who has a defined approval and return policy for paintings, and is willing to listen to your assessment of your resources and not theirs. Then stay within your financial limits.

Following these simple rules, you will minimize buying a painting that turns out not what it was purported to be, you have the opportunity to return what you have decided was a mistake ("eating" them is very hazardous to your health), and that your last purchase will not place you in Chapter 7 or even Chapter 11. After all, wasn't this supposed to be a pleasurable adventure? If your desire was to get rich from your art purchases, you could have tried pork belly futures or maybe a venture capital company pushing fish oil to lower blood pressure and improve self-esteem.

As I have discussed, many collectors feel that an inexpensive manner of acquiring paintings is at auction. This may not be the case, and the risks are substantial as noted earlier. I have certainly acquired paintings in this fashion, but not without considerable preparation.

As noted, the preparation for auction is designed to minimize stress by preventing panic and irrational behavior. Forget the idea that when you bid against a major gallery you are riding along with their expertise and are financially safe because they will mark it up at least 200% when they offer it for sale. The gallery may well be acting as the agent for a collector or an institution that does not possess even your knowledge or judgement. The principal may have told the agent "buy it," so you might very well see the bidding reach the ozone layer. If you allow yourself to follow this ascent to the stratosphere and happen to purchase the painting at this lofty sum located somewhere in outer space, your fall may be very painful. In fact, when reality sets in, you might even wish that you would land on your head so that will dull your sensorium.

If you have any doubts about whether the auction house warrants the authenticity or condition of a painting, read the disclaimers in the front of the catalogue. That is not to say that the major houses don't have experts to

evaluate paintings (because they do) and they also exercise quality control as to what paintings are vetted and which paintings make the auction catalogue. A certain amount of comfort can be taken in this process; but once the hammer falls, you, for all intents and purposes, own the piece that you bid on successfully. If you feel that you have been misled, do not "compound your felony" by considering legal redress. Save your time, funds, and psyche by swallowing the mistake; it may be difficult, but it will protect your health and may even conserve your wealth.

To me, life is a series of gains and losses; success can be measured by how effectively we minimize our losses — not just by the recognition of our triumphs. The most important aspect of this is that rather than pound your gastric mucosa, you must simply accept what has happened and move on to a rapid conclusion. Rumination about mistakes is a great method of depleting one's creative energy and can severely compromise the pleasure of your collecting experience.

Despite a studied avoidance of publicity, if you have been collecting art for a couple of years you will be sought out by the "picker," a cross between a gypsy and a traveling troubadour. Be assured that in many pickers there is the potential of the flimflam man. In the Old West, this breed would have stood on the tailgate of a wagon and hawked some elixir or condensation of snake root. In the art world, the potion is laced with turpentine and varnish. Pickers will often regale you with tales that they supply the leading galleries with paintings that are then marked up 100-200%. Thus, they insist, they can save you this amount. You must resist being impressed with these vignettes and should be mindful that, even if these are not fabrications, a gallery represents repeat business and an ongoing conduit for the picker. Thus, the picker, to preserve their best interests, must maintain a good relationship with the gallery. Also, the owner of the gallery can pass on negative words to the trade and the picker will find himself an unwelcome guest throughout the art world. For these reasons you may not be offered the same opportunities the picker presents to a well known gallery.

There are dealers who do not have an elegant gallery and sell genuinely good paintings out of a station wagon, van, or the back of a truck. The problem when acquiring a painting from a relatively unknown purveyor without a permanent place of business is that they may not have unencumbered ownership and often warrant nothing. Can one receive a genuine painting in this manner at a favorable price? Certainly. Is it risky? Absolutely.

As a collector, you have none of the safeguards a gallery has when dealing with a picker, your leverage is minimal. The condition of the painting according to the picker is always good — though it may need a little cleaning — and provenance is that "it came out of a house." (How could a painting not

come out of a house?) This implies that it is pristine, not a worn piece — sort of virginal. With the picker you are protected only by your knowledge, your judgement and your faith, however misguided, in this individual. Pickers usually have no gallery because they simply cannot conform to a schedule, they sometimes fail to keep appointments, often ship your purchases whenever it suits them, and are in financial circumstances where they are constantly shifting resources from Peter to compensate Paul. You may experience as much chronic hyperventilation and paranoia as Peter and remorse and guilt as Paul after dealing with pickers. Experienced gallery owners treat these people with a great deal of skepticism, and this is despite the inherent safeguards the galleries have that you do not. As an individual who is engaged in this collecting activity for pleasure and not for profit, my advice in the best interest of your health is to deal with pickers only in those areas where you feel you know more than the picker and as much as any gallery.

Physicians are often accused of a conspiracy of silence in failing to warn the public about members of their profession who practice their discipline in a substandard fashion (malpractice). However, there are credentials, standards, and guidelines to protect the public. In medicine, the educational process is rigorous, and credentialing of the participants is reasonably uniform. A great deal of external and internal quality control is exercised throughout the system. The codes of ethics and the concept of community standards carry with them the possibility of loss of licensure and inability to practice. This same characterization may be valid for several other professions as well.

Art also has its educational process and its credentialing bodies. However, one may enter the commercial arena of art with no formal training whatsoever and, after exercising reasonable behavior for a short period of time, receive enough credentialing to keep the public from questioning that person's ability to offer paintings for sale. Since this is not a standardized process, you must depend upon the opinions of other collectors and dealers to evaluate whether you should enter into an agreement to purchase, trade or sell with a specific purveyor of art.

If physicians engage in a "conspiracy of silence," art dealers engage in a "conspiracy of tales." Many dealers have a myriad of stories about the competition involving every possible shortcoming, perfidy, misrepresentation, double dealing, scam, etc. that the human imagination could produce. There are some dealers who have an equal reputation for character and honesty. If you will be patient, these dealers will become apparent and known to you. The fact that they are never mentioned in this litany of evil doing by other dealers, and they are not purveyors of this lore, should tell you that they are what you are seeking in your dealer.

Why do we as collectors, not identify these dealers and have all of our

acquisitions come through them? The major reason we don't, pure and simple, is greed; these dealers appear expensive, and we often want and attempt to acquire art at a "bargain." We continually seek the "pre-owned vehicle" analogy.

Value is what someone can be induced to pay, but as previously noted, the criteria are very subjective. You will sometimes forget everything you have learned about condition, provenance, and authenticity in order to acquire a painting at a cost much below what you convince yourself is its true value. If a dealer, in order to convince you to acquire a work, tells you that they could get much more for the painting from another dealer or if they sold it at auction, ask yourself why you are so fortunate to be the recipient of such an extraordinary opportunity. This is simply the dealer's ploy to enhance your urge to acquire a "bargain."

Art dealers are a critical lot and very litigious with each other and, at times, with collectors. As a collector, you can usually avoid this peril by certain measure such as remaining on a straightforward, simple payment basis for goods received. When you complicate the transaction with a dealer such as trading a painting for value in kind, impose a performance contingency to make the contract valid, or have an extended payment scheme, you increase your chances of litigation several-fold. The lawsuit or threatened litigation may often involve issues that are inherently those of the art world and in which you have little knowledge and are at a great disadvantage. There are a number of areas in human interaction in which litigation is a strong possibility but there seems to be an increased likelihood in art. The personalities of the participants in the contract are such, the potential financial gain can be so enormous, the criteria not standardized, and quality control so unregulated, that litigation is a true potential consideration.

Dealers have been known to trade paintings with collectors in partial payment for an acquisition, and that dealer will have the expectation for the amount they intend to realize from the painting they receive from you. You really have no way of knowing what these expectations are. If the dealer's expectations are not met, you could well be in for the threat of or actual litigation as a method of avoiding the transaction. The damages requested initially by the dealer may even be in excess of that allowed in trade but in line with the dealer's anticipated profit. An example of an "art world condition" I find unparalleled is the anticipated dealer profit. I know of a number of dealers who have sued for the unrealized profit they had projected on a painting from the trade with the client. After the transaction with the collector, the dealer offered the painting at 10 to 20 times the trade evaluation which had been agreed upon by the dealer and collector. The dealer had chosen the painting, believing that due to ignorance, the collector had agreed to an allowed value

in trade which represented only a small fraction of the true worth of the painting. The dealer combined arrogance and greed in this transaction. Failing to achieve the expected profit, the dealer claimed that the painting had been misrepresented by the collector, who felt betrayed by the dealer. The dealer had enlisted an "expert" fellow dealer to declare the painting as "questionable," "a fake," or "not by the artist."

The collector is at a distinct disadvantage in this situation because you are in an unfamiliar arena and are probably unprepared to handle this type of challenge. Another claim by dealers is damage to the reputation of the gallery because of the transaction. This is usually accompanied by a fabricated tale of offering the exchanged goods to a valued client and then having to rescind the offer. If you exchange paintings in kind, make certain what you warrant. Document the value of the credit you have been accorded for your paintings. These experiences may be a matter of conducting business in the rarefied air of the art world but can be very hazardous to your health.

Some self-protection among dealers is not unexpected and is often involved; usually the expert is another dealer who has done and will continue to do business with the plaintiff. *Quid pro quo*, while unstated, is operative. Art dealers seem to use the threat of litigation much more often than competitors or associates in other businesses. Almost monthly, a major art publication will detail the wrongdoings of a dealer in relation to a collector, museum, or another dealer. While this may make interesting reading and might even be suitable for the National Enquirer, it should alert you as to the risks of litigation in the environment of the art world.

Every area of human endeavor has an emotional aspect and ego content, but the art world must place in close proximity some of the most colossal egos and single-minded people that exist. Pride is often worn as an epaulet and, when wounded (even superficially), the response can be incredibly dramatic. In a microsecond, what could be viewed as a disagreement can escalate into threat of litigation. A prudent collector should objectively evaluate and calculate the legal risk of their activities to minimize the chance of litigation, for in this process the "winners," if there are any, are the lawyers.

Avoiding litigation in the art world requires a certain behavioral pattern that some of us have learned through personal experience. I hope my further discussion will allow you to avoid this circumstance altogether. Avoiding litigation is a bit like eluding the IRS audit which can be obviated by having no income and claiming no deductions. However, with regard to the IRS, all one needs to do is escape being found guilty of fraud but the downside risk of litigation in the art world can be even more hazardous. The art world is a litigious environment as I have noted and as you might expect, since much of

its evaluation and validation is based upon opinion and emotion, and is often guided by feelings rather than data. Judgements can be centered on calculations of human value in financial terms with very little credentialing of the participants or standardization of practices.

Prudent behavior in the form of risk management will decrease one's exposure to litigation in any social interaction. Candor and honesty in relationships are obviously qualities that lessen one's chance of risking a courtroom experience. Resist bargains — they probably are not what they seem. Insist upon documented provenance, a certificate of authentication, and a statement of condition of the acquisition. Seek a second (or third) opinion if you have the least bit of uncertainty. Discuss the dealer's return policy and what de-accession assistance you can subsequently expect after purchase. Avoid payment schedules whenever possible. Refrain from trading for value in kind, except with a dealer you know quite well. There is also that bit of traditional wisdom alluding to the canine world about "lying down with mongrels and coming up with vermin." In the art world, it is not fleas but various afflictions such as acute authenticatitis and generalized exfoliative inpainting, which are resistant to cortisone or antibiotics and only partially relieved by large commitments of the currency of the realm.

If an art dealer has a spotty reputation, do not buy paintings from that individual hoping to obtain a bargain. If a painting is not signed, make certain that it can be authenticated through research into the provenance or some other form of conclusive evidence. Dealers will often verbally "guarantee" the author of a work or the authenticity of a painting. If you are prepared to accept this level of documentation and intend to keep the painting for your own use, then you might acquire it, if suitably priced. If you think you might subsequently sell or trade the painting, then pass; avoid future difficulties with authentication at all costs. Despite the fact that an unsigned painting can be reasonably "authenticated," this is a very muddy area in the art world as I have discussed. Rather than fly in the face of conventional wisdom — however flawed — you should probably avoid this entire arena.

If a painting is priced by a dealer much below the market, then you can proceed with several theories as to why it is underpriced. The dealer may not know how much the artist commands; he may be aware that it is a very nonrepresentative example of the author's work; the painting may be in poor condition; or worst of all, it may not be authentic. In polite circles, these are given the appellation of "not right" or in the real world, "fakes." As a sophisticated collector you may know more about any one painting than a dealer. However, this is a dangerous assumption, and remember that it is only your ego involved in this activity but it is the dealer's livelihood. You want to be right; the dealer *has* to be right.

These practices are only safeguards; they will merely lessen the opportunity for litigation. If the threat of litigation is raised, attempt every effort of dispute resolution by settlement, compromise, or arbitration. Avoid the involvement of the legal profession and enter the courtroom with the full realization that the issues will probably not be resolved to anyone's satisfaction, and the emotional and monetary costs could very well be unreasonable, given the value of the paintings at issue. In summary, art can provide you with many pleasures, but litigation is not among them. Litigation is highly probable in certain circumstances, and you must recognize and avoid those.

The issue of authenticity is of such importance, I want to treat it specifically. As I have noted, the principal determinant of a painting's value is the stature and reputation of the artist who composed the work. Thus, the importance of authenticity is almost unparalleled in the appraisal of any particular work. The correctness of this circumstance notwithstanding, the fact is that this represents the conventional wisdom in the art world, and the historical precedents to determine authenticity are rigidly and steadfastly held despite some rather flawed reasoning and problematic logic in this exercise. The application of scientific tests to the authentication process has merit but is not without significant limitations. Radiographic (x-ray) images cannot authenticate paintings nor can computer analysis of stroke and pigment application patterns, but they can provide evidence. An expert's opinion is also evidence but a different type and less subject to evaluation.

The criterion initially evaluated in assessing the authenticity of a painting is most commonly the signature of the artist. So important is this determination that there are texts devoted to the appearance, signature, inscription, or symbols artists might have used to indicate that they are, indeed, the creator of the painting. Variations of their known signature are included because many artists, as one might expect from creative people, changed their signatures throughout their careers. In fact, some artists even changed their names or altered the composition of their inscription.

Edmund Tarbell, the leader of the Boston Museum School, signed his paintings by a variety of signatures which are, by now, quite well known to the collecting public, as there has been a well publicized controversy regarding the authenticity of many examples that presently are in private hands. J. Alden Weir was at one time Julian A. Weir, and James Abbot McNeill Whistler, about whom all things were extraordinary, used a monogram suggesting an Oriental inspiration. This technique was copied by the Dabo brothers, who also wanted to emulate the other characteristics of Whistler's tonalist aesthetic. The Boston artist, Louis Kronberg, often but not always affixed the Star of David with his signature. It was probably a very bold statement at the time but did not dissuade Isabella Stewart Gardner ("Mrs. Jack") from collecting his work.

Some artists worked their signatures into the painting in such a fashion that they are almost undetectable by simple visual inspection. William Louis Sonntag, a well-recognized landscape artist of the mid to late 19th century, often so intricately wove his signature into the brushwork of his paintings that you could search unsuccessfully for it by simple visual inspection. These almost undetectable inscriptions may sometimes be uncovered by raking or black light inspection. "Soft" (low kilo voltage) radiographs may also uncover signatures. Signatures can be hidden beneath the frame liner or mat of a painting and can be uncovered when the painting is cleaned or restored.

The quest of a signature can sometimes achieve the character of a journey in search of the Holy Grail, and one's thinking can be so distorted that the logic then becomes: If a signature is uncovered, then the painting is genuine; and if one is not identified, the painting is not authentic. The signature, rather than a means to an end (authenticity), becomes the end itself. A signature is *evidence* for authenticity, not equivalent to authenticity itself.

Collectors, dealers, and conservators have experienced all of the above-noted revelations enough to pursue each of these avenues if there is some chance it will lead to the discovery of a signature. However, extrapolating from the autograph and document collecting world, the fashioning of a signature or a symbolic inscription to perpetuate a deceit is not extremely difficult or that uncommon. Given the temptation of significant profit, little chance of detection, and minimal legal risks, misrepresentations will predictably occur. Not only is this perfidy difficult to uncover, but determining exactly when the deed was performed during the chain of ownership may be virtually impossible. Thus, for you to discover specific culpability is problematic and makes restitution difficult.

Another widely held belief in the art world is that by the considered analysis of the brush stroke and composition pattern, an "expert" can determine the artist who painted the work with great accuracy. While this is a time-honored evaluation and certainly has validity and inherent merit, the manner in which it is accepted defies certain proven concepts in science, well-validated positions in the canons of human logic, and takes great license with the legal concept of evidence. Brushstroke analysis by art experts has been likened to fingerprint or DNA analysis, genetic matching, and possibly magnetic resonance (MRI) spectroscopy. These scientific techniques, however, are objective measures that may even lend themselves to quantification, while brushstroke analysis is inherently subjective and not in a format that the degree of certainty can be measured. An appropriate analogy might be identifying the culprit from a police lineup in which the chronological age of the subject is unknown and recognizing that the physical characteristics of human suspects can vary significantly over time, as can the appearance of a painting.

Subject matter of the painting at issue is another parameter which experts often use to lend credence to their identifications. However, anyone who has seen the intact estate of an artist, participated in the gathering of examples for a retrospective of someone's oeuvre, or accumulated a *catalogue raisone* has discovered that what is considered to be the characteristic subject matter of an artist, or that for which they are known, and the scope of subjects an artist might have painted over an artistic lifetime varies a great deal. Therefore, what is "typical" may well change over time.

In the formative stages of their careers, artists might have attempted a variety of subjects, styles, and media that they later abandoned forever. The requirements during their academic training may well have dictated that they compose images of certain subjects fulfilling the desires of the school and not necessarily their own. These paintings later may come to be judged as atypical and nonrepresentative, but they are not without authenticity. For an expert to declare that an artist "would never have painted ..." approximates abandoning human logic and is at best conceptually flawed.

Compositional materials are subject to scientific analysis and can often document temporarily when a painting was executed but will certainly not identify the artist. This type of dating may very well eliminate an artist who was deceased at the time that particular painting material or support device was introduced or used with regularity. Thus, scientific analysis and not expert opinion could tell you who did not paint a specific painting. Paper, support, and pigment analysis have not been as widely applied as their value and objectivity would suggest that they might. I believe this is because the methodology is expensive and, thus, only appropriate when the subject at issue is above a baseline value. You simply would not do this on a painting valued in the low hundreds or even thousands for that matter.

The art world has certain beliefs that are so steadfastly held that they become "absolutes." However, I have seen experts often revise these "absolutes," which are quite often based on opinion and not compelling data. An example of changing of conventional wisdom was the idea held for years that Benson "did not do pastels." This was later revised when pastels came on the market from well-established sources and with impeccable provenance. I later noticed advertisements by noted Boston dealers of "rare" Benson pastels. Today it is so well accepted that Benson did pastels that if these pastels were offered for sale they would likely be described as "by the noted artist Frank W. Benson," casting aside the previous "absolute." To even espouse the concept that a particular artist never produced an image using such a common medium as pastel I believe represents a departure from standard deductive reasoning, but old saws die slowly and the pronouncements of experts have extraordinary meaning in the art world.

I once acquired a pastel by the Charleston and Woodstock artist, Alfred Hutty, who is known for his compelling watercolors of landscapes and Black life in the South after the "War Between the States" in the early decades of this century. This pastel, which depicted a typical road in lowland South Carolina framed with live oaks laden with moss and the characteristic palmettos, was acquired at an antique mall located in eastern Massachusetts. The owner believed it to be a rendering of the "Boston Botanical Gardens where they have those tropical plants."

I asked several persons associated with Hutty's estate about this unusual example. They informed me that they had "never seen a pastel by Hutty," suggesting the medium somehow disqualified the work or tacitly meant it could not be an authentic work by that artist. This revelation challenged my imagination, so I attempted to discover the provenance of this piece which, incidentally, had a very nice "Hutty" signature. The owner of the mall who sold me the painting had acquired it from the estate sale of a storage unit in Brooklyn. The work had been placed there more than 20 years ago by the decedent who collected art in the summer in Woodstock, New York, area. Hutty, of course, had a summer studio in Woodstock.

The facts in the case end there, but for logical analysis to bring the data into context you should also know that Hutty painted and conducted an art school in Charleston at the same time that Elizabeth O'Neill Verner created her extremely popular images of Black life utilizing pastel as her most common medium. These two artists were contemporaries, colleagues. Would it be too illogical for an artist like Hutty, who wrote texts on printmaking and etching, to see how well he could handle pastels? From the example I have, Hutty was very successful in at least one attempt. The circumstantial evidence of the provenance, place of discovery, and method of acquisition in my opinion outweigh "conventional wisdom" and are very compelling.

This personal reference leads me to the subject of provenance in the quest for authentication. The history of a painting can provide crucial evidence to its genuineness. Evidence is usually legally defined as "that data or fact that will assist in the search for truth" — in this instance the truth is the identity of the artist who is responsible for the painting in question. Knowing the circumstance under which your painting was executed as well as subsequent ownership and exhibition records will provide significant evidence of the painting's authenticity. A well-documented provenance is much more difficult to fabricate than a signature and much easier to evaluate than someone's opinion — no matter how expert. Documentation by verbal testimony, written description, or photograph that a specific painting was executed by a particular artist may not be *prima facie* but it can represent almost irrefutable evidence.

I can, however, recall some questioning by several prominent dealers of the

authenticity of a major painting by the visionary artist, Ralph A. Blakelock, in my collection. This is understandable as Blakelock was commonly faked. I had rather conclusively documented the provenance of my painting, which had been purchased from the artist and owned by the wife of the Barbizon artist, Charles Gruppe, later his son Emile, the well known Rockport impressionist, and even later, Virginia Gruppe Quirk. Even with this provenance I sent the painting to the Blakelock scholar, Norman Geske, who "authenticated" it as a Geske Category I (the highest mark) which was readily accepted by all. If one examines this litany under the best evidence rule, the provenance would be very difficult to fabricate and, with all due respect to Professor Geske, his testimony is but an informed opinion. My point is that you may be able to uncover what may be the very best evidence — the true provenance.

Why may an exhibition record be important in evaluating the authenticity of a painting? It documents public exposure and the opportunity for the painting to have been seen and appraised for its aesthetic value and authenticity by many people. The curator of the exhibit also is presumed to have had a certain level of expertise and, in agreeing to include the painting in the exhibition, has at least tacitly accepted its authenticity. Publication of the work as an illustration in a catalogue, text, or monograph provides additional evidence that there may have been public acceptance of the work's authenticity. Again, the selection of the painting by an art historian or curator for publication communicates their acceptance that it is generally what it is purported to be. For these reasons, you should insist upon knowing and having documentation of the provenance and the exhibition record of any painting you are considering for purchase, if this is available.

Despite this discussion, can you as a collector, feel totally assured that the authenticity of a painting will be unequivocally accepted if the evidence is overwhelming according to common logic? I will offer several personal examples which I hope will be informative — and entertaining. The authenticity of one of "The Ten" in my collection was challenged (declared a "fake") by an expert despite the fact that the sitter was known, the circumstances of execution and the provenance were documented, a signature had been present and documented prior to restoration, and the painting had been in three exhibitions and published in a catalogue and two texts. This painting had been on semipermanent loan in a major public collection for several years. Upon subsequent "review", the painting was later declared genuine. The expert had judged it from a photograph and was not aware of, nor did this expert request, the provenance — the courtroom equivalent of an attorney appearing sans a brief (possibly Pete Sampras without a racquet or Michael and no Air Jordans). Much to my dismay I later found out that this was the methodology used by this dealer to void a contract as well as to appear to be an expert.

Another painting of mine by a leader of "The Eight" was included in a museum exhibition of the late artist's work. At preview night, a relative of the artist told the curator "I have never seen this work." Despite the fact that the sitter of the work was known, the painting was signed and inscribed, and the painting had been published as an illustration in a monograph and a cover for a magazine article, the museum director and curator felt from that statement, that the work was "questionable." The museum asked permission to remove it from their local exhibition but that it would be included in the travelling collection — I deem this truncated logic at best. I agreed to the process rather than having a confrontation and due to the fact that this "questionable" painting would still be seen at eight museums during the travelling exhibition. Later we found the artist's inventory number on the obverse, but I felt it was unnecessary because the challenge of its authenticity had been totally without scientific merit by any standard. Authenticity is sometimes an ethereal concept and not always established on the one hand or challenged on the other by deductive reasoning or a logical process.

You might learn several truths from these two rather amusing experiences. First, in the art world, the concept of evidence or evidence itself is not always treated in the same manner as it is in law, logic, and science. Also, the fact that an expert has written a text on the artist does not make them infallible in judging the authenticity on works by that painter. I have written over a dozen texts on medical imaging techniques, but I could not correctly identify or authenticate every image used as an illustration, even in these texts, and certainly not in all related ones. Writing a text certainly does not convey absolute knowledge or infallibility. The art world seems to often fall prey to the type of logic which reasons that authorship connotes omnipotence in a specified area. In considering authenticity in the second vignette, a statement by a relative of the artist would have validity only if one presumed that the relative had seen all of the paintings ever executed by the artist — a blatant impossibility.

These events demonstrate that in a relative desert of scientific principles, conclusions are often driven by emotion rather than data. The substantiation of authenticity by well documented evidence is often lacking because the research and due diligence have simply not been done. In this circumstance, the fate of a genuine work can rest solely upon the opinion of someone who may be both informed and expert but not infallible. As the collector you should gain all the data about your painting that is available before and subsequent to acquisition. You can feel you have addressed the issue of authenticity as best you can. Afterwards, enjoy your "real" paintings and never accept anyone's "logic" unless its validity appeals to you.

You now have a collection which presumably you enjoyed acquiring and

are satisfied with the results. These paintings embellish your home and office. They give you pleasure to look at them as well as recall the manner and moment of your acquisition. For reasons of health alone you might cease and desist, but some collectors will not do so. They want to feel the "rush" that occurs when one sees their name on the identifying museum plaque stating "on loan from the collection of ..." Even more permanently rewarding is to be mentioned and recognized in an exhibition catalogue. These represent public exposure.

Another order of magnitude of personal exposure and hopefully reward is to loan your collection for exhibition. The anticipated pleasure, however, is not without some risk to your health. You cannot always correctly anticipate the public response to your artistic judgement. First the museum staff and curator are going to accept only what they feel appropriate, arrange the exhibit to their standards, and probably describe your works according to their assessment of the artistic merit. Then there is the risk of damage and theft. When you loan paintings, if the exhibit travels, how will it be enclosed and shipped and when will it return? How well is the exhibit insured? Will temperature and humidity be regulated? Sharing one's collection with the general public can tax both your cardiovascular and central nervous systems. I know collector friends who cannot attend openings involving their own paintings for fear of public rejection or criticism.

With my very first exhibit, in removing the paintings after the show the "consultant" hired by the institution punctured a painting. This was the first time I had the opportunity or challenge to determine who insured the works, and if there was adequate insurance or just whose insurance applied. Should you or the institution have replacement insurance or only enough to cover your acquisition cost? Much more important for me was whether or not the damage to the painting would decrease its value — no matter the competence of the restorer. After about the tenth "expert" opinion about what should be done with the painting, I got a second opinion about the headaches I was having. If you believe that you are going to be fully compensated for significant damage to and subsequent devaluation of a painting, you will be disappointed.

People usually invest a great deal of emotion in their personal tastes. These go on trial when you loan paintings for public exhibition. Having one of your paintings rejected by the curator as a "fake" will place you into acute shock, but to be told that your painting represents a social faux pas will predictably put you into a state of seething anger and indignation. This, in your gestalt, is a personal insult.

A nude by George Luks that for years was part of my permanent collection, was also typical of both the artist and his circle, as well as being a moderately important painting. In going through an exhibit containing this painting with some friends, I noticed that my Luks was missing. My theories as to the cause

of its absence ranged from damage at the exhibition to theft. When I finally located the curator, he apologetically told us that "certain patrons" had found the painting offensive and had demanded its removal. After our respective heads came down from the ceiling, I demanded to have an audience with these "arbiters of taste" so that I could inform them about the Ashcan School of artists, nudes in general, George Luks' typical nudes, realism, etc. Fortunately, the curator did not comply with my heated demands for an audience and my anger soon passed, but I learned a real truth. If you exhibit art outside the confines of your private space, you are subject to the whims and vagaries of the public. If your emotional composition cannot accommodate their response, to protect your health, modestly and reluctantly but firmly decline to exhibit publicly. Sort of like the temperature and the kitchen.

What if I make an error? Mistakes are a part of the collecting process. An acquisition that seemed appropriate at the time may upon reflection appear to have been an error. As a collector, you should not ruminate, second guess, or punish yourself. Merely develop a strategy to de-access the work. There are a number of alternatives and you should consider each to select the most appropriate for you. You must recognize that as your tastes become more refined, or your interests shift, or you may have a simple change of mind about a specific painting, you should respond to this by appropriate de-accessions. It may have been a good acquisition at the time, but now it should be a good de-accession using the appropriate methodological choice.

I do not wish to discourage you from being or becoming a collector in the full sense of the activity and the broadest context of the meaning. However, you should have a realistic appraisal of the risks involved and behave in a prudent manner to ensure a long and healthy art collecting career. It is much easier to prevent a stroke than to cure one. You can improve your health and feeling of well-being by periodically assessing the reality of your activities and expectations and engaging frequently in a risk/benefit analysis.

Thus, collecting has some degree of risk, but so does every human endeavor — just minimize those you can control and accept those you cannot.

23
Postmortem

Collecting paintings can be rewarding at many levels, as I hope I have made clear through some of my vignettes and personal opinions. For some collectors the acquisition process provides even more pleasure than the subsequent ownership. To others, sharing their collection through loans and exhibitions provides the ultimate enjoyment.

In everyone's collection there are special paintings that may be important to you for a variety of reasons. Most of us can recall vividly our first "serious" acquisition. They may even have kept this sacred example of their initiation as a reminder of when and under what circumstances the process began. Most collectors will also remember their most difficult acquisition or the one requiring their greatest financial sacrifice. I certainly can. Other paintings may achieve a special category for less private or personal reasons. Some of these may represent what we believe to be an important phase in the artist's career, portray a subject which renders the work to be a part of art history or depict an event or a place of special artistic or historical importance to us. For example, I have an oil sketch used as a presentation piece for a commission of the mural at the City Hospital of Indianapolis. This piece has achieved significance far beyond its artistic importance because structural renovations much later sacrificed the mural. The only existing visual record of a cooperative civic endeavor in the early decades of the 20th century, between the leading Hoosier artists and the public health care system for children, is this painting.

Landscapes characterizing the Old Lyme, Woodstock, New Hope, Brown County, and Hoosier group paintings showing specific locations such as the artist's home or studio become much more valuable to me as a collector than their aesthetic qualities alone. My T.C. Steele of his home "Tinker Place" (which was also the first temporary location of the school) was chosen as the cover for the catalogue "Indiana Impressionism."

A painting in my collection executed in 1903 by Henry Ward Ranger of his new studio in Noank, Connecticut, reminds me of his disappointment that the American Barbizon art colony he initiated at nearby Old Lyme came to embrace impressionism under the influence of Childe Hassam and J. Alden Weir. In 1903-1904, Ranger left the Griswold Mansion where he had been the leader since 1898 and encouraged his colleagues at Old Lyme to move to

Noank and Old Mystic. Ranger realized that impressionism was going to eclipse his favorite Barbizon manner of painting and left disappointed and frustrated. However, the Old Mystic colony produced some important works and Ranger was somewhat vindicated in that he made the change to another location, set up this studio and continued to influence other artists. Another reason I am impressed with Ranger is that at his death he willed several hundred thousand dollars for museums to acquire paintings by American artists. So, when I see a plaque "Purchased by the Henry W. Ranger Fund," I think of my painting of his studio.

One of my favorite paintings has always been the Griswold Mansion at Old Lyme by Childe Hassam. In this stately house, administered and ministered by the matriarch, Florence Griswold, lived a number of the young artists which painted together. In the summer they painted the picturesque environs of this beautiful Connecticut coastal town. Some of America's most compelling impressionist masterpieces were rendered at Old Lyme not only by the famous members of the colony such as J. Alden Weir, Willard Metcalf, and Childe Hassam but by lesser-known artists as well. I was always attracted by the nostalgia of this image. Although I do not own the Hassam painting, my nocturne of the Griswold Mansion by the little known B.K. Howard is to me a special painting nevertheless. The subject more than compensates for whatever shortcomings of artistic merit it may possess. When I acquired this painting at auction for something in excess of five times the estimate, there were other resolute collectors present who had succumbed to the same nostalgia. I felt this acquisition was justified because the subject matter had particular significance — it was to me a special paining and I rationalized paying a special price for it.

Sometimes a painting can become special even though it has been acquired purely for its aesthetic appeal. This can be viewed as the reward for your own research or conversely, the "even a blind hog will stumble over an acorn" theory. I purchased William Starkweather's "The Swing" purely upon its artistic merit while knowing nothing about the artist. This was an auction I attended in order to purchase another painting that I had missed at a small estate sale and could not get the dealer to sell to me later. He thought it was a "block buster" and wanted to try his fortune in the auction arena. I did not get the painting I came for but purchased this lovely work by Starkweather and subsequently learned that he was one of the group of painters at Old Mystic. The next summer, I was visiting the Mystic, Essex, Old Lyme area and learned from Mystic's senior art patron that the house and children in the paintings belonged to an artist friend of Starkweather. I visited the house which is on a lovely promontory. This fortuitous bit of independent data has elevated this particular painting to the special group of my collection. It was probably the

most popular work in a subsequent Starkweather retrospective and a gift from me to one of my children who expressed appreciation for its inherent painterly qualities.

One of my favorite collections is the 60 to 70 portraits I acquired over a 3-to-5 year time period. One of the more intriguing aspects of self-portraits by artists is how they have chosen to represent themselves during various stages of their lives and careers. Some will choose to be representative and documentary, while others attempt to make a statement through the posture, dress, or surroundings they choose for these paintings. Portraits were part of the ritual of entry into the National Academy. Such portraits were meant to be representative of the artists' virtuosity but in addition provided an opportunity for the artist to convey some aspect of their personality and character.

After I saw the exhibit of the National Academy entitled "Artists by Themselves," I became very interested in the meaning of this type of artistic expression and I have since acquired a number of self portraits or those of certain artists by their contemporaries whenever I have had the opportunity. My portraits of Asher B. Durand's wife by Gilbert Stuart, Jane Peterson by Robert Reid, Lilla Cabot Perry by Frederick Boseley, and self portraits by Henry Hammond Ahl, and J. Ottis Adams are among my favorite paintings not only for their artistic merit but what I believe must have been a special effort for the artist to capture the essence of the sitter; in the later instance, "artist know thyself."

Self portraits or paintings of the artists' wives, close relatives, or children of the artists represent an emotional investment by the artist that makes these paintings particularly interesting and, in my opinion, very desirable. I believe this is particularly relevant for portraits of the artists' relatives and children. Once I was able to acquire at auction an unsigned painting of John J. Enneking's daughter because I had seen a photograph of her and remembered her distinguishable physical characteristics. This represented a special painting for Enneking and posed an opportunity for a special acquisition by me. It has and will always hang in my home.

As equally interesting as self and family portraits to me are those paintings which portray a fellow artist, either as a figure study or, even more appealing, practicing their trade. This was my greatest attraction for the Robert Reid, as Jane Peterson is shown with brushes and palette and robed in a smock typical of artist's attire. Paintings which depict students at their easels in the atelier working with a live model are always special for a collector. My "Luks in Studio" was chosen as the inside color cover by my publisher for the Thomason text. Almost any casual student of art or experienced collector can identify John Singer Sargent's painterly work of Paul Helleux at his easel while resting with his wife in a small boat among the reeds. Don Hoopes,

recognizing this, made it the cover of his seminal book on American impressionism.

There are various motivations for collecting paintings. As I have discussed throughout this text, this is reflected by the myriad of reasons certain paintings in your collection may be special for you. "Special" has many connotations, and I hope that my thoughts will cause you to reevaluate your paintings from a somewhat different perspective and to trust your own judgement and instincts in acquiring paintings for your collection. After all, your collection should be your own personal statement of what you find interesting, desirable, and valuable.

You do not have to be wealthy to have a representative art collection, especially if you enjoy the collective activities I think this requires. We would all like to own a major Winslow Homer, William Merit Chase, or a John Singer Sargent. The simple fact is that most of us cannot; especially if we plan to acquire the work by conventional methodology. Accept this fact or figure out an unusual strategy to do so. You probably will never write a text that will compete with one by Bill Gerdts, John Wilmerding, or Don Hoopes... but you can fashion a brochure or catalogue that is a smaller but significant contribution. Your collection may not match that of Charles T. Evans, Dan Terra, Charles Lang Freer, Walter Annenberg, Richard Manoogian, or Thomas Gilcrease but yours can represent quality, scholarship, and good taste. What is really important is that you enjoy it and that it provides immediate and long term satisfaction. Collecting paintings has greatly enhanced my life, provided me with unique experiences, and has resulted in pleasant memories. Hopefully this process will do the same for you.